Joan

Miró

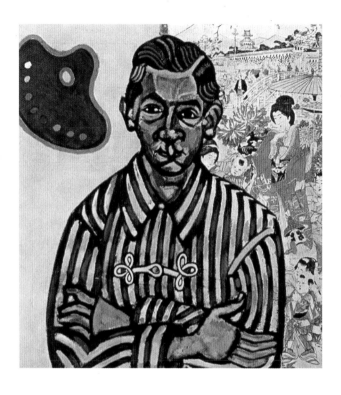

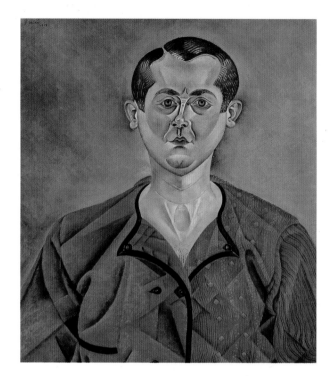

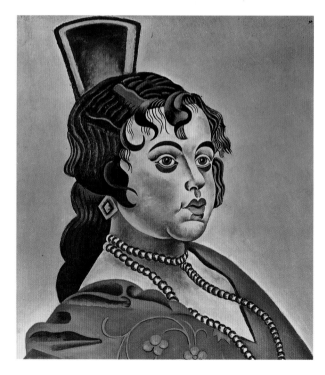

Text: Susan Hitchoch

© 2005 Sirrocco, London, UK (English version)

© 2005 Confidential Concepts, worldwide, USA

© 2005 Estate Miró / Artists Rights Society, New York, USA /
 ADAGP, Paris

ISBN 1-84013-766-5

Published in 2005 by Grange Books
an imprint of Grange Book Plc
The Grange Kingsnorth Industrial Estate
Hoo, nr Rochester, Kent ME3 9ND
www.Grangebooks.co.uk

Printed in China

Joan

Miró

Grange BOOKS

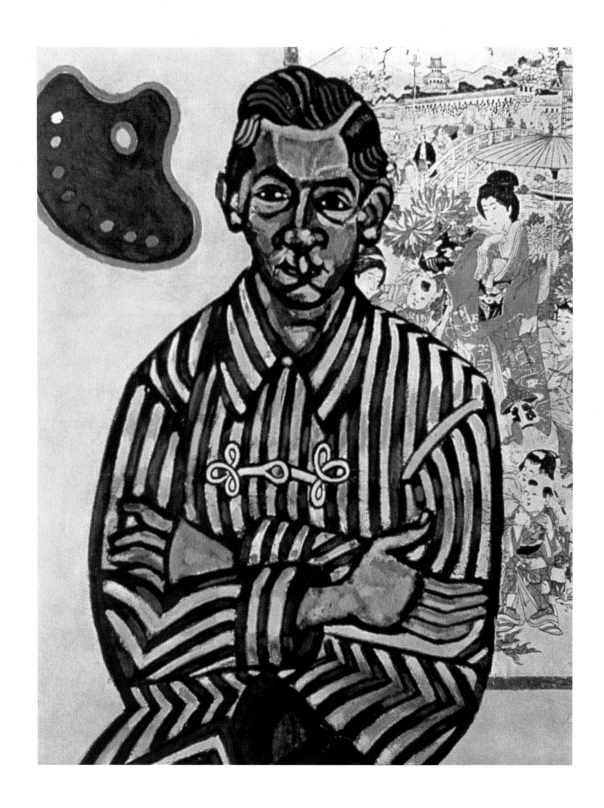

Joan Miró i Ferrá was born in a room with stars painted on the ceiling. He grew up in the city of Barcelona, where rugged independence and creativity go hand in hand. Along with the Catalonian spirit of originality – neither Spanish nor French, but enjoying its own unique history, language, and culture – came a permanent sense of belonging to the Mediterranean countryside. Miró's father, the son of a blacksmith, worked as a goldsmith and watchmaker. His mother was the daughter of a cabinet-maker. His father's family came from the seaside village of Montroig in the province of Tarragona, and his maternal grandmother still lived in Palma, the sun-drenched village on the island of Mallorca. They all came from peasant stock, and in Catalonia, the rebel peasant – the man who wears the red wool cap and works the land with bare hands – is the hero. In the city, the Catalan capital of Barcelona, the architect is the hero: particularly Antonio Gaudí, who, at the turn of the 20th century, grasped the Gothic tradition and turned it into something modern, fascinating, and distinctively his own. Joan Miró grew up admiring both, peasant and artist.

Miró was born on April 20, 1893. He was the first of two children; his sister, Dolores, was born four years later. At seven, he entered primary school in Barcelona. He was a very poor student, a dreamer who had little to do with his classmates. They teased him about his sensitivity and called him "egghead." To make the school day tolerable, Joan Miró stayed late in the afternoon to take drawing classes. "That class was like a religious ceremony for me," Miró wrote nearly seven decades later. "I washed my hands carefully before touching the paper and pencils. The implements were like sacred objects, and I worked as though I were performing a religious rite... I drew the leaves of trees with loving care."[1]

His drawings from this early period are remarkably meticulous: carefully rendered with line and shade. The first works of art from the hand of Miró were lifelike representations of a fish and a vase of flowers. In three years' time, though, the adolescent's imagination had begun to play with reality, and a 1906 vase of flower sits atop a pedestal of striking perspective, its branches nearly symmetrical and dotted with distinctly drawn leaves, its four-petaled flowers topping the design.

Released from school each summer, Miró relished the carefree times he spent with family in Tarragona and Mallorca. He often stayed in Palma with his grandmother, a romantic woman who no doubt provided a welcome release from the authoritarian discipline of his father in the city. In Palma, the young Miró filled sketchbooks with simple charcoal line drawings of the local scenery: fishing boats, Palma's cathedral, the windmills of El Molinar, and Bellver Castle.

1. *Portrait of E.C. Ricart,*
The Man in Pyjamas,
1917. Oil on canvas,
81 x 65 cm.
Private collection,
Chicago.

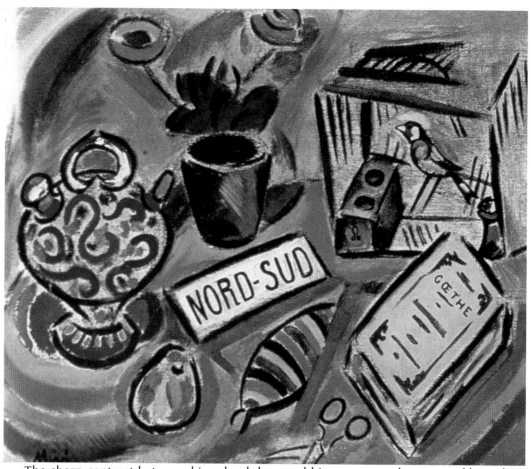

The sharp contrast between his school days and his summers, the rigors of his urban life in Barcelona and the freedom he felt in the country, would continue to echo throughout Miró's life. Not only would he move with the seasons, alternately working in studios in Paris and the Spanish countryside, but his work would also mediate between the two poles of his creative personality, between poetic spontaneity and systematic method. Powerful dualities would also be harnessed in his art. The ornamental would oscillate with spare lines and flat planes of color.

In 1907, under pressure from his father, Miró entered Barcelona's School of Commerce. At the same time, just as he had done before, he sought in his art a way to tolerate the necessary. He enrolled in art classes at La Escuela de la Lonja, an academic and professionally oriented school of applied arts where a young man named Picasso had impressed the teachers ten years earlier. Miró did not garner such a reputation. He did not follow the rules quite so well.

2. *North-South*, 1917.
 Oil on canvas,
 62 x 70 cm.
 Private collection, Paris.

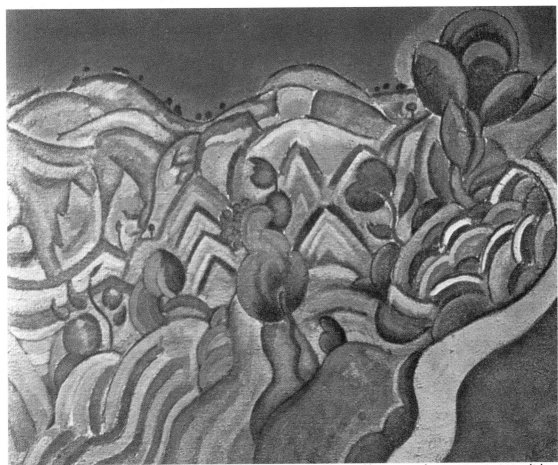

"I was a marvel of clumsiness," Miró recalled of himself as a student at Lonja.[2] He did, however, win the regard of certain art teachers whose own artwork roamed beyond the bounds of the practical even if their classroom lessons did not.

As he reached adulthood, Joan Miró dutifully took a job as a bookkeeper for a Barcelona trading company, abandoning his art for the moment. "I was very unhappy," he later recalled. But art was deep within him, and he could not keep his hand from drawing in the ledger books. He was, as he later put it, "more and more given to daydreams and rebellion." It did not take long before he fell seriously ill with depression, complicated by a case of typhoid fever. He left his city job and convalesced in Montroig, in a farmhouse recently acquired by his father. This episode seems to have convinced his father to give up all ambitions for his son as a businessman, for when Miró's health returned, his path took him straight into Francisco Galí's Escola d'Art.

3. *The Path, Ciurana,*
 1917. Oil on canvas,
 60 x 73 cm.
 Private collection, Paris.

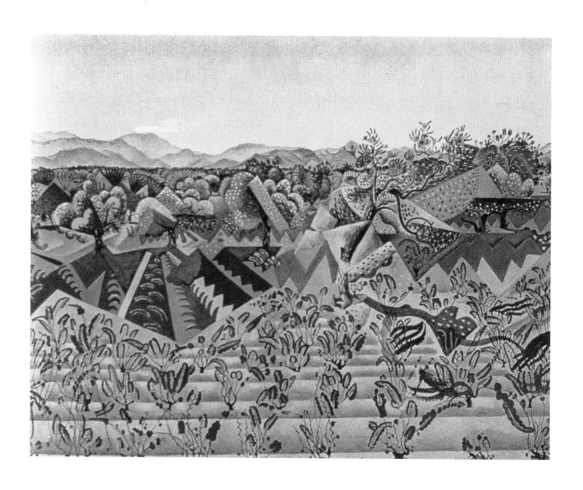

4. *Montroig, Vine, and Olive Trees*, 1919. Oil on canvas, 28.75 x 24 cm. Private collection, Palma of Mallorca.

Unlike the Lonja School, Galí's private classes offered a setting where Joan Miró's distinctive ways of seeing were rewarded. Galí was known more as a teacher than a painter, more a patron of the most modern of arts than a practitioner himself. He interviewed students before he accepted them. It was in Galí's classrooms that the young artists of Barcelona were discussing Impressionism, Fauvism, and even cutting-edge Cubism, represented in the new work of Pablo Picasso, the fellow Spaniard who was making such a splash in Parisian art circles. Joan Miró quickly proved himself to his teacher. Assigned to paint a still life of colorless objects including a glass of water and a potato, Miró created, in Galí's words, a "splendid sunset" of color.[3] Miró's eyes saw well, and his imagination saw even better.

Miró came into Galí's school with a strong sense of color and left with an even stronger sense of form. The teacher would hand the young man an object to hold behind his back, asking him to feel it, then reproduce it on paper.

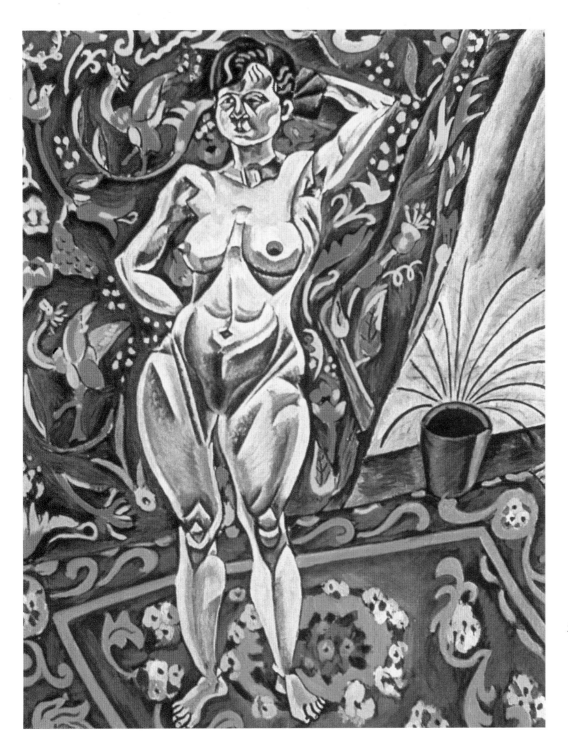

5. *Standing Nude,* 1918.
Oil on canvas,
153.1 x 120.7 cm.
Saint Louis Art
Museum, Saint Louis,
Missouri.

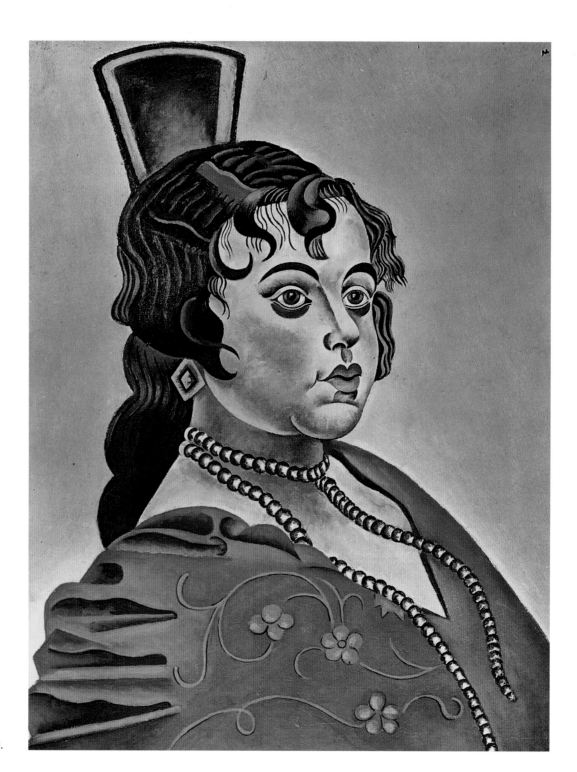

6. *Portrait of a Spanish Dancer,* 1921.
Huile sur toile,
66 x 56 cm.
Musée du Louvre,
Paris (donation Picasso).

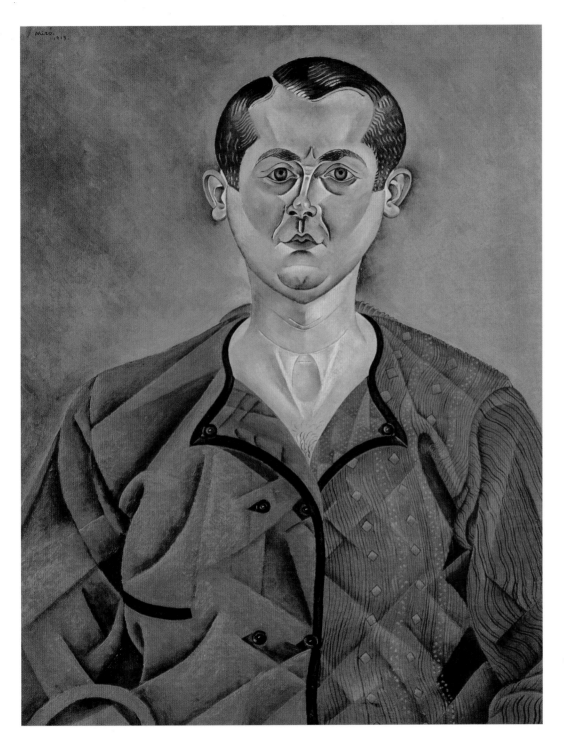

7. *Self Portrait,* 1919.
 Oil on canvas,
 73 x 60 cm.
 Picasso Museum, Paris.

Galí took his students on trips into the countryside, never allowing them to sketch while traveling but rather assigning them to draw landscapes from memory once back in the studio. In his old age, Joan Miró still remembered these challenges. He put his own version of them to his grandson, Joan Punyet Miró, who wrote that the two of them would take walks together, the elderly artist always encouraging the young boy to make a special effort to learn "how to listen to the silence, how to look at things in the dark, how to communicate without words."[4]

At Gali's academy, Miró met some of the men who would become not only fellow artists but intimate friends. He and Enric Cristòfol Ricart soon rented a studio together near the Barcelona Cathedral. It was an exciting time to be an artist in Barcelona, a refuge for French artists whose country had recently gone to war. Young artists joined together to form an independent drawing group called the Sant Lluch circle, a brash reaction to the existing art circles of Barcelona. The Sant Lluch artists did not adopt a regimented style of their own, and their eccentricity suited Miró. Later identified as a Surrealist, Miró really never espoused any school or established style of art. "It was clear in his mind," as one critic has put it, "that he had to go beyond all categories and invent an idiom that would express his origins and be authentically his own." Over the course of his career, he even worked hard not to follow his own traditions.

The Sant Lluch artists pooled their money together to hire models to pose for them. Many of those who came to the drawing sessions were young upstarts like Miró, but others were ageing veterans. At one of these sittings, Miró had the honor of sketching alongside the great architect Gaudí himself, who still valued the camaraderie and the opportunity to draw from life. Members of the Sant Lluch circle roamed the late night haunts of Barcelona, but Miró quickly gained a reputation as the first among them to go home to bed.[5] He never succumbed to the romantic excesses of the dissipated artist, choosing instead to lead an orderly and temperate life.

In 1912, any artist saw his work against the palette of the Impressionists. A large exhibit of French art came to Barcelona, giving Miró and his friends the chance to become familiar with paintings by Degas, Monet, Gauguin, Monet, and Seurat. Josep Dalmau ran a gallery on the Calle de la Puertaferrissa, exhibiting even more cutting-edge works by painters including the daring French Cubists Fernand Léger and Marcel Duchamp. There Miró met Francis Picabia, who had just founded 391, the magazine that would become the voice of the Dadaist movement. New ideas about art were in the air. Cubists painted the world in planes of shape and color. Marcel Duchamp saw time as a series of flat planes, too, as best depicted in his famous *Nude Descending a Staircase*, painted in 1913. "Dada is a state of mind" stated the poet André Breton.

8. *Still Life with Toy Horse*, 1920. Oil on canvas.

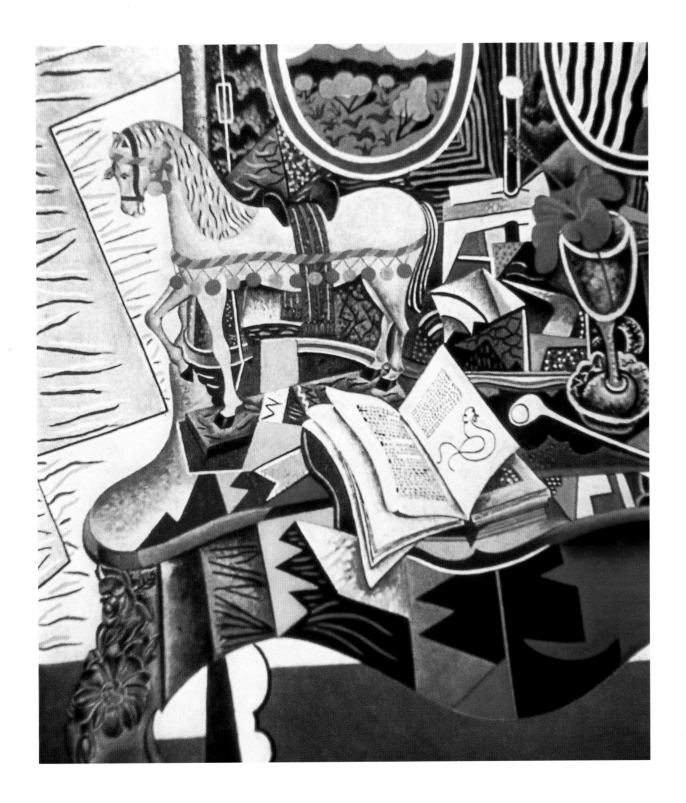

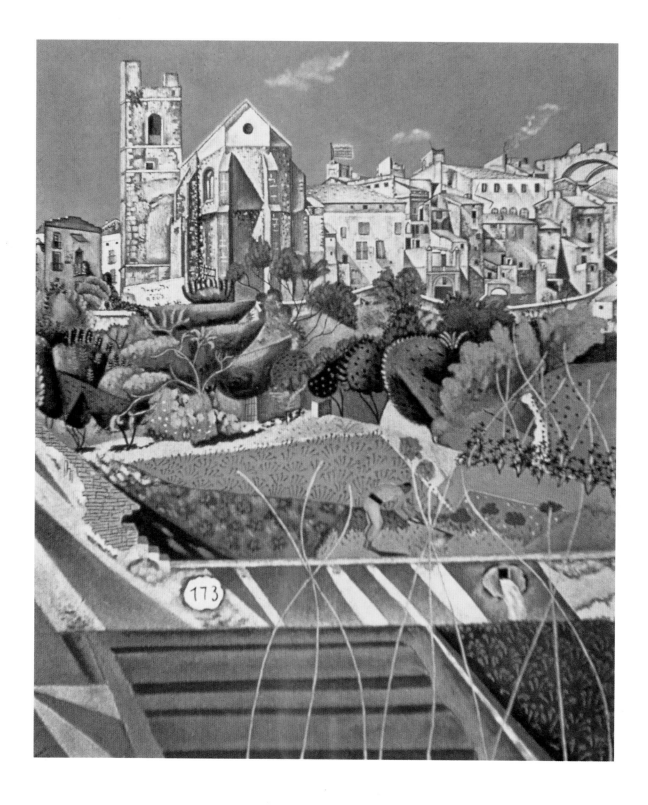

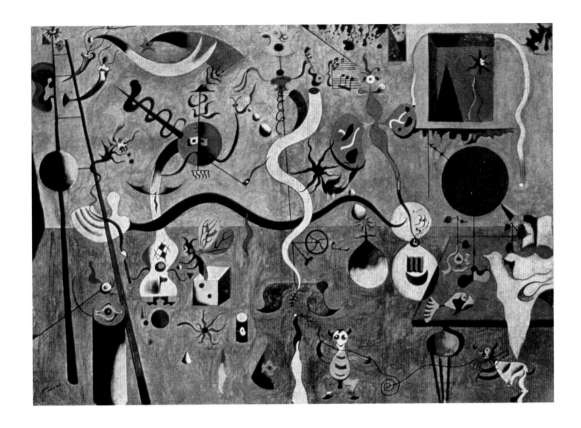

Painting could not express the full Dadaist philosophy. It was an effort to break the rules – a school of thought whose central tenet was that no school, no thoughts should predominate. "How can one get rid of everything that smacks of journalism… everything nice and right, blinkered, moralistic, Europeanized, enervated?" asked German writer Hugo Ball, author of the movement's first manifesto. His answer: "By saying Dada."[6]

Impressed by the way Miró used shape and color in landscapes and portraits, Dalmau promised him a one-man show. Clearly the young man had studied Cubism's broken forms and had learned to admire the strident colors of the Fauves. But he had an eye of his own, and his paintings combined twisted perspectives, heavy brushwork, and surprises in color. He was finding ways to merge the stylish two-dimensionality of the times with inspirations taken from Catalan folk art and Romanesque church frescoes. Miró painted feverishly during the year 1917. His first exhibit at the Dalmau Gallery, held from February 16 to March 3, 1918, featured more than 60 paintings and drawings.

9. *Montroig, Village and Church*, 1919. Oil on canvas, 28.75 x 24 cm. Private collection, Palma of Mallorca.

10. *The Harlequin's Carnival*, 1924-1925. Oil on canvas, 66 x 93 cm. Albright Knox Gallery, Buffalo.

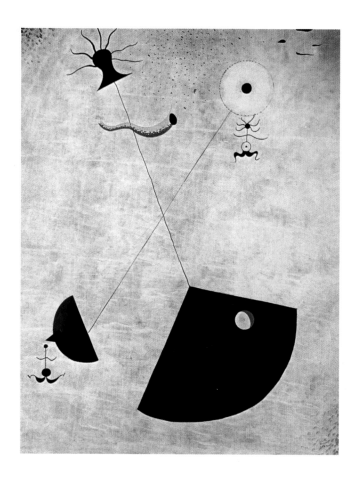

Portraits, still lives, landscapes – all shared bold lines, vibrant colors, and a willingness to reduce the intricacies of the visible world into a designed chaos of irrefutable shapes. *Standing Nude,* the masterpiece of the show, juxtaposed a human body, its muscle masses sculpted into strong geometric statements, against the raucous clash of two different swatches of cloth. Behind the nude woman hangs a Mallorcan tapestry, primitive patterns of birds and flowers in joyfully primary colors. Beneath her feet lies a mauve carpet, more sophisticated, symmetrical, and subdued. This pitting of pattern against pattern, style against style, fascinated Miró, characterized many of his early paintings, and foreshadowed the explorations he would later make in his more fantastical paintings.

As if recoiling from the bustle and success of his first art show in the city, Miró retreated to Montroig and embarked on a series of landscapes now remembered as his first foray into poetic realism. He did with his landscapes what he had done with his nude in a decorated room, seeking the swatches of color that other eyes may not see,

11. *Maternity,* 1924.
Oil on canvas,
92 x 73 cm.
Private collection.

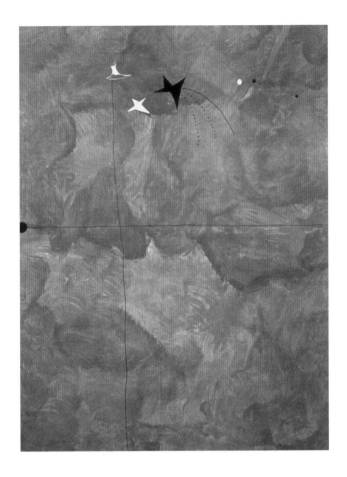

juxtaposing geometries and establishing patterns that were repetitious yet endearingly a little bit different with each iteration. In *Vines and Olive Trees, Montroig* (1919), he practically states his intentions on the canvas. The horizon looms in the distance, hills lifting in traditionally soft curves and colors. Closer in, trees and bushes turn into chunks of pointillist color. A swath of primitive sawtooth patterns, flat shapes of yellow, green, and fuchsia, breaks the progression. Close in, plants painted with loving detail sprout from parallel rows, as if to show that from the linear and predictable erupts the unexpected, the one-of-a-kind.

"As I work on a canvas, I fall in love with it, love that is born of slow understanding," Joan Miró wrote a friend in 1918, explaining what he considered his slow pace of painting. "Slow understanding of the nuances – concentrated – which the sun gives. Joy at learning to understand a tiny blade of grass in a landscape. Why belittle it? – a blade of grass is as enchanting as a tree or a mountain.

12. *Head of a Catalan Peasant I*, 1925. Oil on canvas. Private collection, Stockholm.

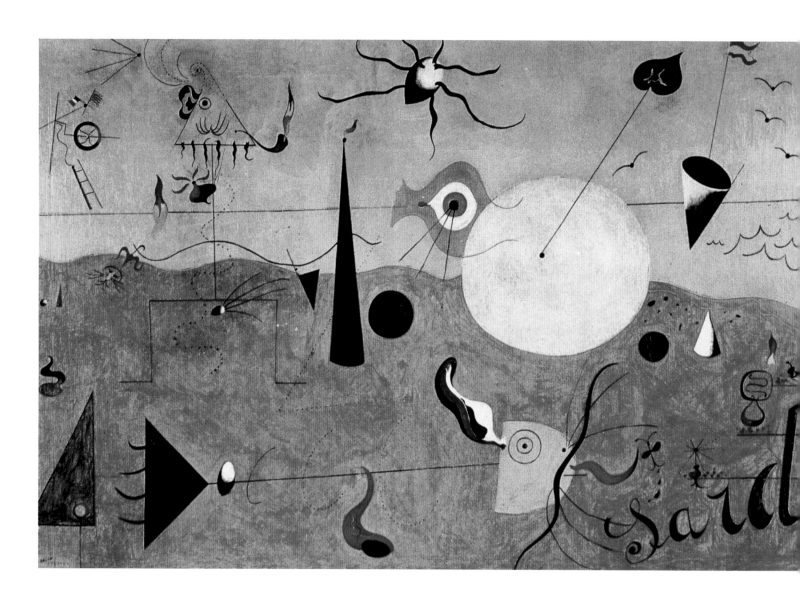

13. *Catalan Landscape*
(*The Hunter*),
1923-1924.
Oil on canvas,
64.8 x 100.3 cm.
Museum of Modern
Art, New York.

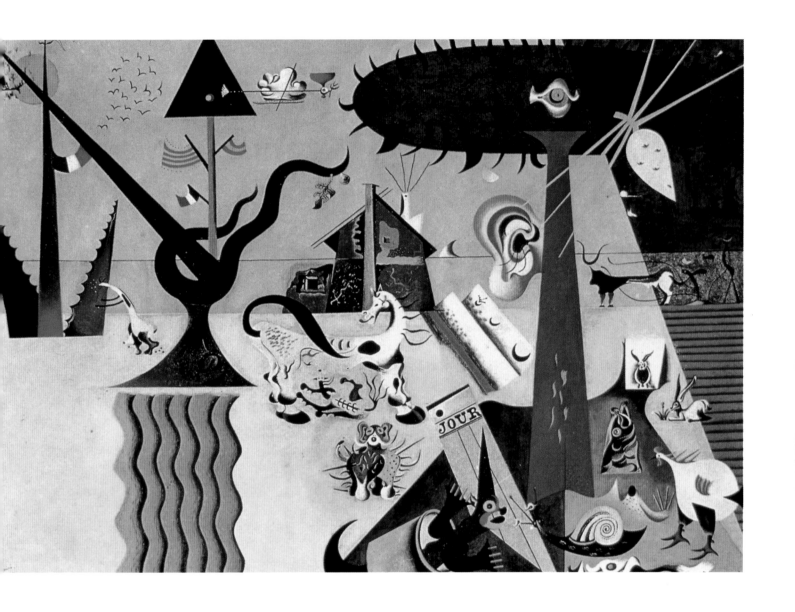

14. *The Tilled Field*,
1923-1924.
Oil on canvas,
66 x 94 cm.
Guggenheim Museum,
New York.

"Apart from the primitives and the Japanese, almost everyone overlooks this which is so divine. Everyone looks for and paints only the huge masses of trees, of mountains, without hearing the music of blades of grass and little flowers and without paying attention to the tiny pebbles of a ravine – enchanting."[7] In this same letter, he expressed his view that an artist should strive for classicism, working directly from life and from nature. He questioned the creative power of any artist who could not fulfill an academic assignment and create a realistic still life or landscape. "I detest all painters who want to theorize," he wrote. His retreat from the city was also a retreat from the rhetoric of artist-philosophers, those who generated more words than they did canvases.

To support himself as an artist, though, Joan Miró recognized that he needed the city – and not just Barcelona but Paris, now that the war was over. "The essential thing is to have the road paved and a safety net so I won't break my neck if I fall," he wrote a friend in 1919. "The best time to try to do anything is as soon as possible…I detest people who are afraid to fall in battle and content themselves with a relative, very meager triumph among a handful of imbeciles in Barcelona."[8]

"Paris, Paris, Paris" – arriving in the French capital, Miró wrote a letter to a friend with nothing but those three words. "This Paris has *shaken me up* completely," he wrote soon after. "*Positively*, I feel kissed, like on raw flesh, by all this sweetness here…I spend the entire day at museums and looking at exhibitions."[9] He stayed in Paris for three months, from May through June. He roamed the museums and galleries, soaking in all the imagery and colors he could, and attended a few classes at the Académie de la Grande Chaumière, although it appears that he did not sketch or paint anything he considered worth keeping. He called on Pablo Picasso, who greeted Miró as a countryman and a friend. They formed a bond that would last all their lives. By this date, 1919, Picasso had successfully exhibited his work in Paris and London. He saw the glow of artistic genius in his visitor and insisted on purchasing the ingenuous *Self Portrait* that Miró had painted in Spain and brought with him to Paris.

Joan Miró began to recognize that, like Picasso, if he was going to become an artist in earnest, he needed to move to Paris. "I should a thousand times prefer," he wrote a friend, "to be an utter failure, to fail *miserably* in Paris, to being a big frog in the stagnant pond of Barcelona."[10]

He sold all his paintings to Dalmau to make money to return to Paris, asking a low price on the condition that the gallery owner organize a Paris exhibition once he had new work. Dalmau managed to make such arrangements, and Miró's first Paris show opened on April 29, 1921.

15. *The Farm*, 1921-1922.
Oil on canvas,
132 x 147 cm.
National Gallery of
Art, Washington.

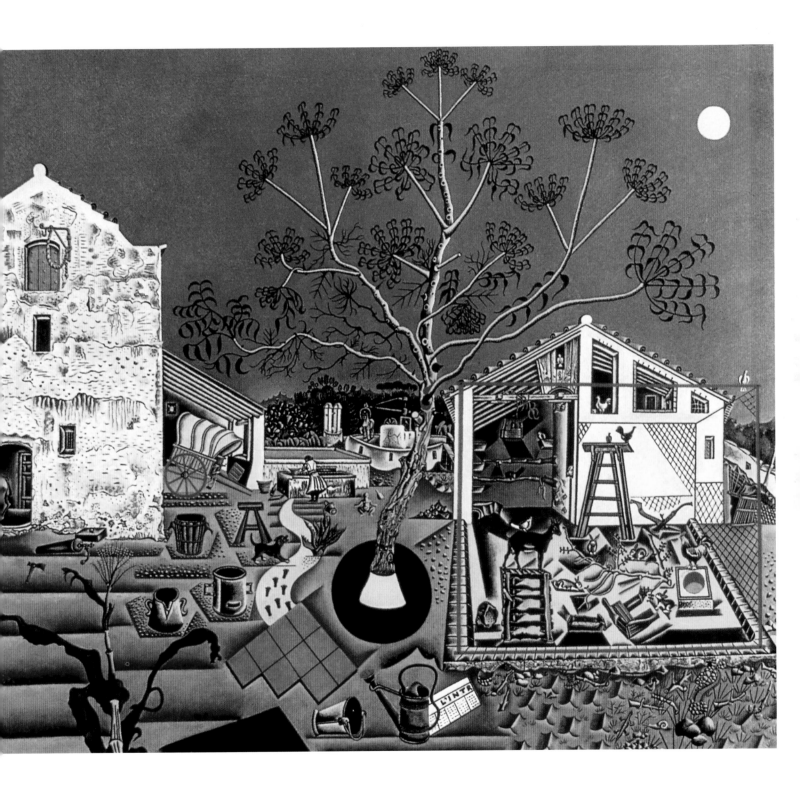

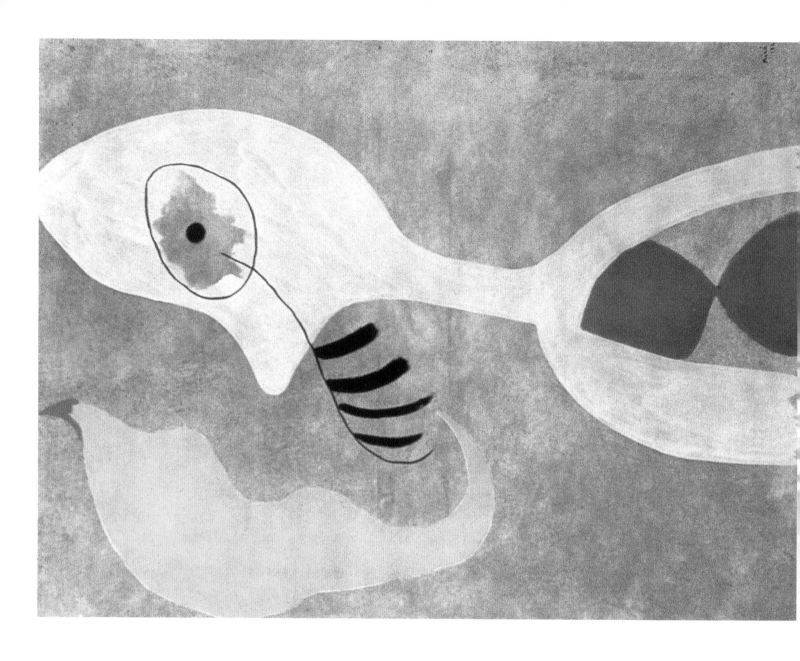

16. *Head of a Smoker*,
1925. Oil on canvas,
64 x 49 cm. Private
collection, London.

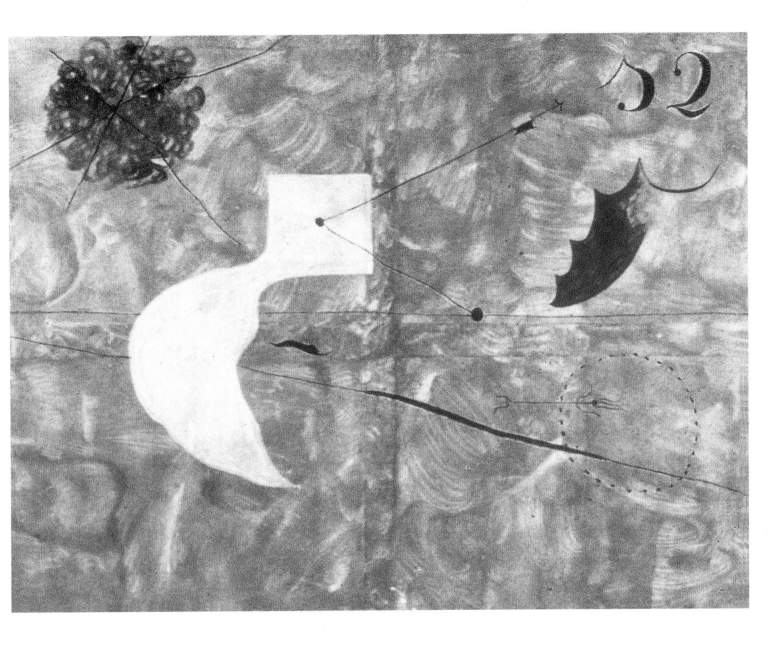

17. *Siesta*, 1925.
Oil on canvas,
97 x 146 cm.
Musée National d'Art
Moderne, Centre
Georges Pompidou,
Paris.

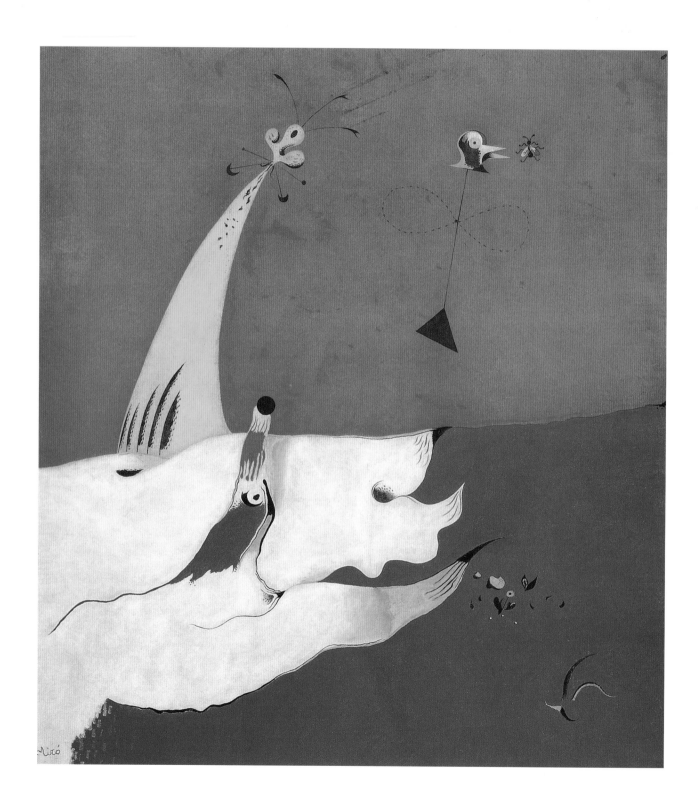

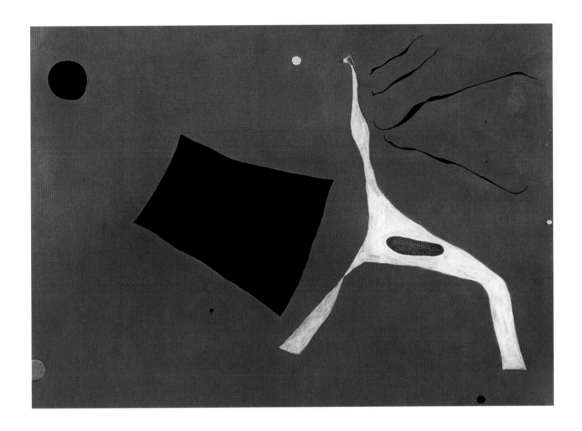

It closed two weeks later with little notice and not a single painting sold. The show's catalogue contained words that in years to come would appear a prophecy. The author congratulated the painter for letting chance contribute to the "play of the imagination." Because of it, the catalogue read, "we can say that it is when he is at his most audacious that Miró executes his most striking paintings."[11]

In the wake of this inauspicious beginning, Miró began a watershed painting. *The Farm* – the "hymn to the house where he convalesced and lived,"[12] as one critic has called it – was to be the grand finale of his period of poetic realism. This single painting collects in abundance so many details that he loved and remembered about his childhood and early home: a eucalyptus tree spreading broadly at the canvas's center, the implements and animals of farm life, the furrows of the field, the uneven surface of a stucco-walled farmhouse, the gawky stalks of corn, the plump stalks of sempervivum. He took more than a year to paint it, and during that time shuttled between Montroig and Paris, strengthening his ties in the urban artist's community then retreating to the countryside he loved so well.

18. *Landscape*, 1924-1925. Oil on cvanvas, 47 x 45 cm. Museum Folkwang, Essen.

19. *Circus Horse*, 1927. Oil on canvas, 129.8 x 96.8 cm. Private collection, Brussels.

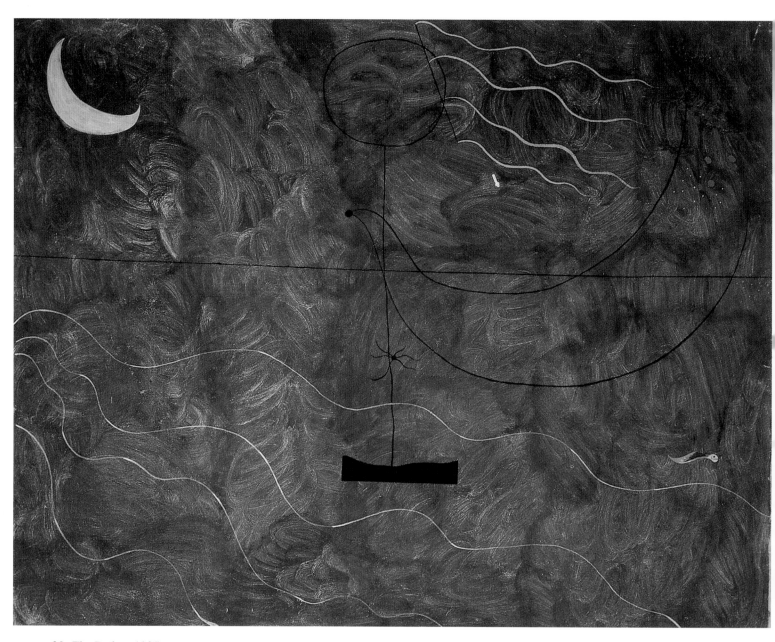

20. *The Bather*, 1925.
Oil on canvas,
73 x 92 cm. Musée
National d'Art Moderne,
Centre Georges
Pompidou, Paris.

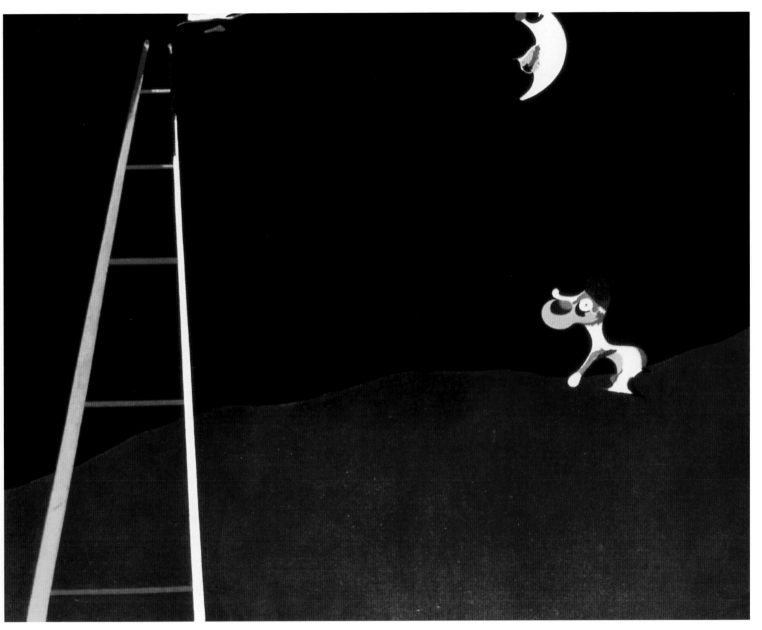

21. *Dog Barking at the Moon*, 1926.
Oil on canvas,
73 x 92 cm.
Philadelphia Museum
of Art, Philadelphia.

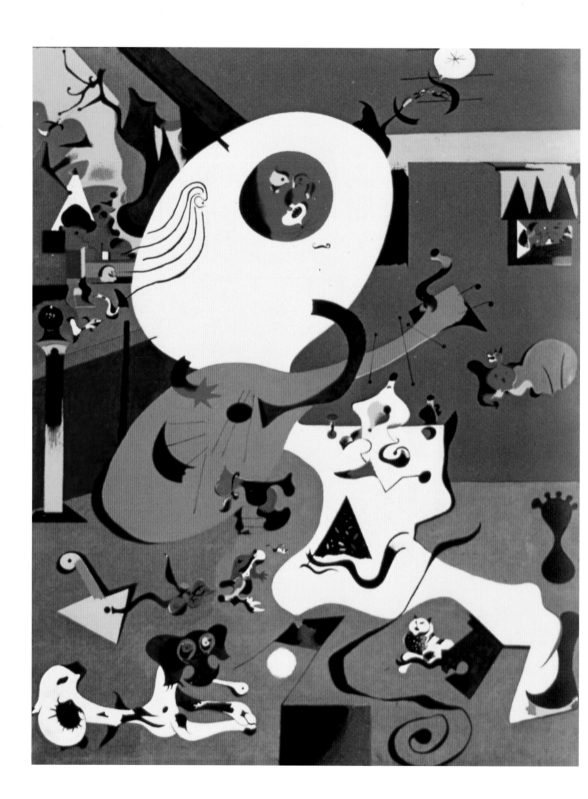

22. *Dutch Interior I*,
1928. Oil on canvas,
91.8 x 73 cm.
Museum of Modern
Art, New York.

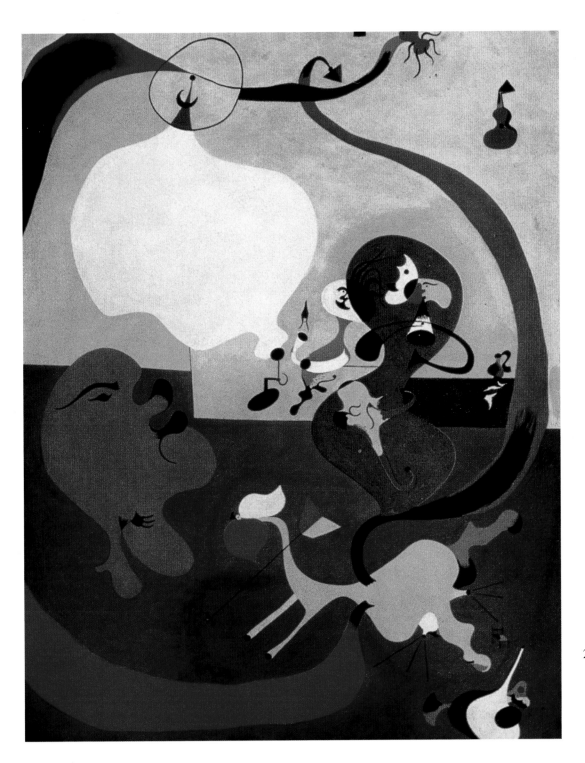

23. *Dutch Interior II*,
1928. Oil on canvas,
92 x 73 cm.
Guggenheim Museum,
New York.

On top of the busy details of farm life, the painter layered in geometric lines and shapes, flattening them out amid the three-dimensional perspective: a red square outlines the barnyard, a slice of terra cotta tiling ends a foot-printed path. The path leads to the only two people visible in this busy, patterned landscape: a woman washing clothes in a trough and, behind her, at the base of the eucalyptus tree, a small naked figure, squatting, hands outstretched: a baby? A primitive icon? Miró himself?

It was a rich tableau of images, colors, shapes, and symbols. Miró carried it from gallery to gallery in Paris, but no dealer would show it. Finally it hung for a night in a Montparnasse café, drawing the admiration of fellow artists if not patrons wealthy enough to buy it. It became the property of American novelist Ernest Hemingway, who later recalled how the canvas billowed in the open-air taxicab as he carried it away. "At home we hung it and everyone looked at it and was very happy," he wrote. "I would not trade it for any picture in the world."[13] Miró himself told Hemingway he was content to see it hanging in his apartment.

Although he regularly retreated to Montroig, Joan Miró began to consider Paris his home. For a while he rented a studio at 45 rue Blomet, next door to the painter André Masson. Masson was just the first link in an entire community of artists with which Miró found a home, just as they were beginning to coalesce in the movement of art and sensibility they called "Surrealism." It was a movement of thought that at once extolled the individual and the imagination and at the same time flaunted tradition, rationality, and even common sense. In words offered by the author of the movement's manifesto, André Breton, Surrealism was "thought's dictation, in the absence of all control exercised by the reason and outside all aesthetic or moral preoccupations" – which made room for just about any sort of creative act, as long as it was unique and unusual. A reliance on "automatic" creativity – letting the paintbrush or pen flow without apparent conscious control – was one of the techniques that the Surrealists favored. Their products of poetry and art flew in the face of convention – the more outrageous, the better. It was as fertile an intellectual ground for Joan Miró as the olive groves of Catalonia. "He had arrived at the French capital at the ideal moment, a revolutionary instant when his talent was coming to the boil," wrote art historian Lluis Permanyer.[14]

His Parisian contemporaries helped release in Joan Miró a new freedom to abstract the world he knew and saw. He held fast to his sense of geometry and color, but he began to show the world in shape and symbol, not representational imagery. Miró called it "the absolute of nature" and told a friend in 1924 that "my landscapes have nothing in common any more with outside reality. Nevertheless they are more 'Montroig' than if they had been done 'from nature.'"[15]

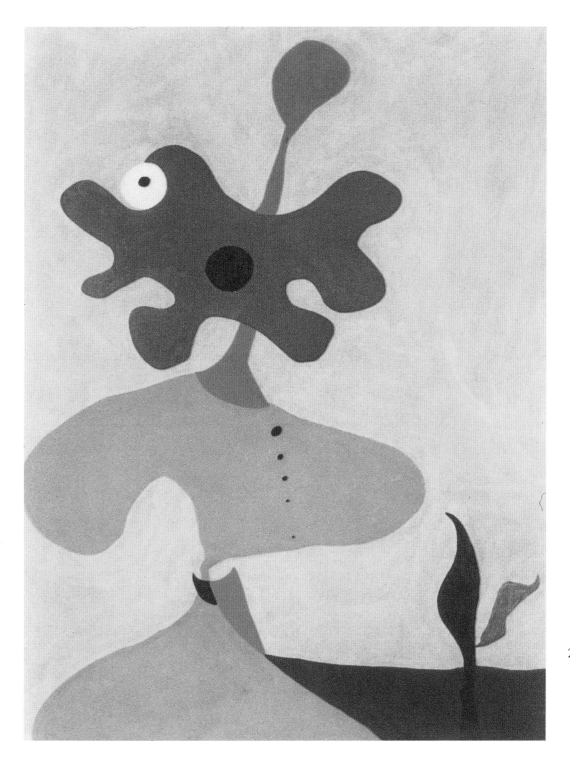

24. *Portrait of a Lady in 1820*, 1929.
Oil on canvas,
91.5 x 73 cm.
Private collection.

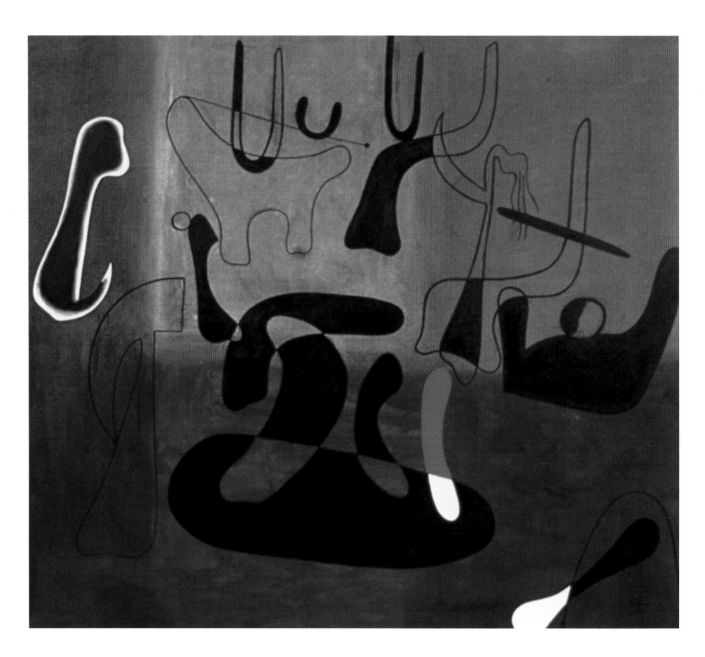

25. *Painting,* 1933.
 Oil on canvas,
 173.36 x 196.22 cm.
 Museum of Modern Art,
 New York.

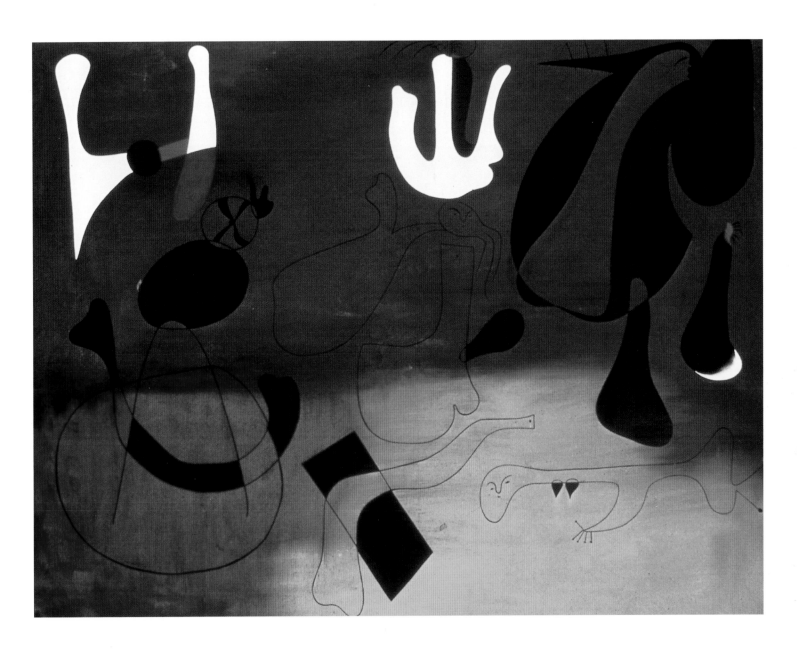

26. *Composition,* 1933.
Oil on canvas,
130.18 x 161.29 cm.
Wadsworth Atheneum,
Hartford, Connecticut.

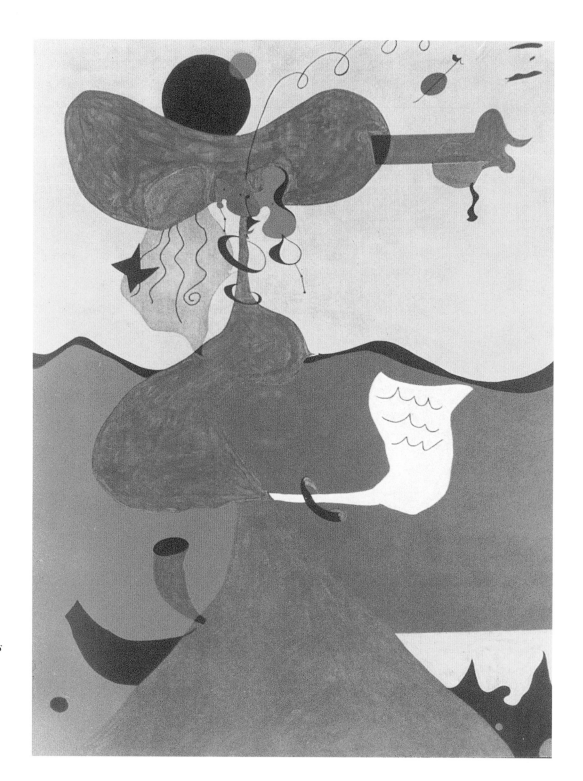

27. *Portrait of Mrs. Mills
in 1750,* 1929.
Oil on canvas,
116.7 x 89.6 cm.
Museum of Modern
Art, New York.

By 1925, he could paint a sky-blue canvas, quartered with black lines, ornamented with two four-pointed stars, one black, one white, and brought to life with dashes of red – and call it *Head of a Catalan Peasant*.

Meanwhile, he was living the life of the starving artist. His living quarters were cramped, his studio spaces mere cubicles, his budget near starvation-level. "It was a very tough period," he recalled much later. "The windows were broken, and my stove, which had cost forty-five francs at the flea market, didn't work. But the studio was very clean. I did the housework myself."

"Being very poor, I could only afford one lunch a week: the other days I had to settle for dried figs and chewing gum."[16] Hunger piqued his imagination, ironically, and Miró externalized the hallucinations that it brought on to create the drawings that became his famous painting, *Harlequin's Carnival*. "I would come home at night having eaten nothing all day and put my feelings down on paper. I spent a lot of time with poets that year because I thought it was necessary to go beyond the 'plastic fact' to achieve poetry."[17]

The Tilled Field, the first of Miró's truly "flat" paintings, demonstrates the drastic turn his landscape art was taking. Working more indoors, distilling the essence of nature in forms that arose in his imagination, he now built on what he learned from Gali, drawing objects on which he had never laid his eyes. He was instead looking for the absolutes, the abstracted forms – "new organizational concepts," as art historian Margit Rowell has put it: "stream of consciousness flow, constellations of connected or disconnected signs, fields of saturated color – signs floating in space."[18] Jacques Dupin, Miró's biographer, heralds this as the moment when Joan Miró discovered his own style.

Influenced by the practitioners of surrealism, Miró never really joined their ranks. The joyful freedom espoused by the Dadaists was more to his liking than the manifestoes and dogma of the Surrealists. His naïve originality drew the attention and admiration of them all, however, and he was soon the favored illustrator for the magazine *La révolution surréaliste*. His one-man show at Galerie Pierre opened at midnight on June 12, 1925, drawing a crowd and causing a sensation. "The paintings on the wall dumfounded those who could get a look at them," wrote gallery owner Jacques Viot. "But I think that the artist amazed even more because nobody could figure out any connection between his works and his person."[19] Wearing an embroidered waistcoat, gray trousers, and white spats, Joan Miró adopted the appearance of a meticulous gentleman – nothing like an artist set to turn the world upside down with his new way of looking at it.

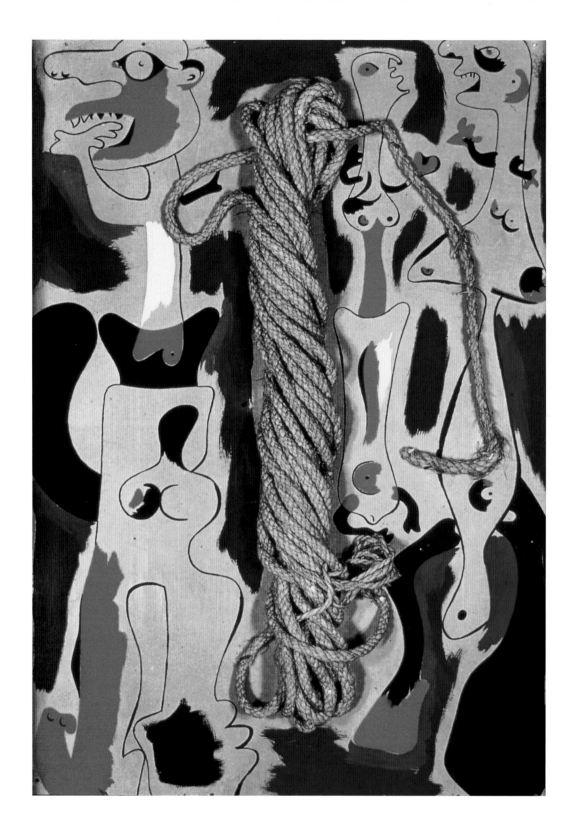

28. *Rope and People I*,
1935. Oil, cardboard,
wood and rope,
104.7 x 74.6 cm.
Museum of Modern
Art, New York.

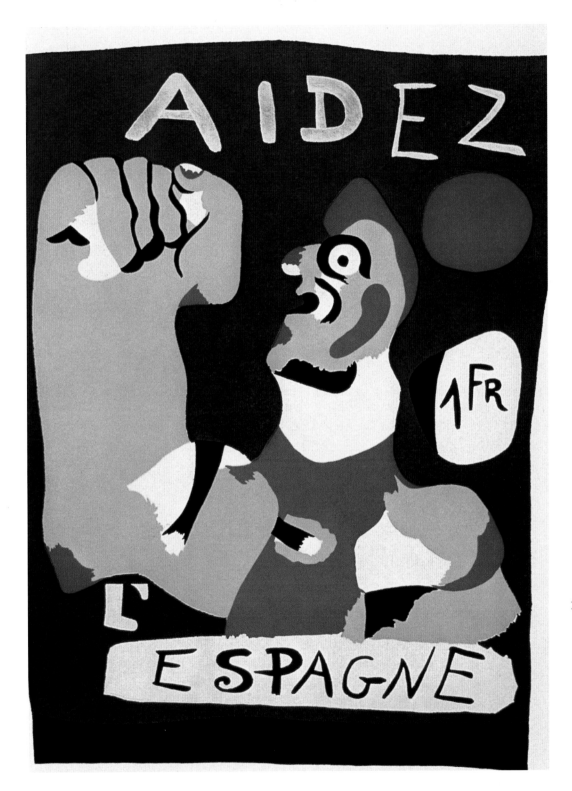

29. *Aidez l'Espagne (Help Spain)*, 1937.
Colour pochoir with lithographed text
24.7 x 17.2 cm (image),
31.8 x 25.3 cm (sheet)
Fine Arts Museum of San Francisco, San Francisco, California.

The Birth of the World, produced in 1925, displays how Miró explored Surrealist ideas in his challenge to traditional easel paintings. "It is the first of a long series of visionary Surrealist works which deal metaphorically with the act of artistic creation through an image of the creation of a universe," writes Rowell. The very process of creating this painting mirrored some sort of cosmic creation. Beginning with a blank canvas, or "void," the artist created a primary chaos by treating his canvas with glue, sizing it unevenly so that paints would adhere irregularly. Miró followed with a series of transparent glazes, in some places spread with a rag while wet.

Now the painter/creator could step in and apply his intelligence to the work. He haphazardly flicked paint over the surface of the canvas, allowing accidents to inspire him. When a splotch of black needed to be bigger, he made it into a triangle, and then added a tail.[20] Miró allowed himself the liberty to explore the colors and shapes in his own imagination in his dream paintings, created between 1925 and 1927, which have only the slightest hint of relationship to an external world.

More secure in his role as Parisian artist, Miró relocated to Montparnasse in 1927. His new neighbors included artists and poets: Max Ernst, Hans Arp, Pierre Bonnard, René Magritte, and Paul Eluard. After travels to Belgium and Holland, he embarked on a fascinating series of paintings that he called *Dutch Interiors* – distinctively Miróesque reinterpretations of the Dutch masters, guided by museum postcards he brought home. Pencil studies show how he transformed the realistic paintings into fantastical cartoons of their underlying structures, while the final paintings reflect his characteristic transformation of a shaded world into large, flat shapes of bright, bold color. The counterpoint between realism and fantasy continues throughout the career of Joan Miró – it is the genius of his art, which makes it both accessible and mysterious.

"Miró's preoccupations, and his genius, were mythic in character," writes Rowell. Like all mythmakers, he "shows an attempt to remember and conserve not facts or dates but exemplary events and archetypal heroes and to actualize them as meaningful images in the present." While he soared with the other great Surrealists into realms of the imagination, he never lost his footing in his earliest Catalan identity. He ensured that by continuing to spend the summer in Montroig, he never lost sight, literally, of the landscapes of the Mediterranean countryside. Miró's mythmaking gains from the richness of "Catalonia itself: its light, its soil, its tilled fields, its beaches" as well as its women and birds – to Rowell, "the most constant mythical figurations depicted throughout his long and varied oeuvre."[21]

By the late 1920s, Miró's painting had matured into a style that combined the mythical and the wholly new, the representational and the abstract, childlike naiveté and symbolic sophistication.

30. *Persons Haunted by a Bird*, 1938.
Chalk and watercolor.
Art Institute of
Chicago, Chicago.

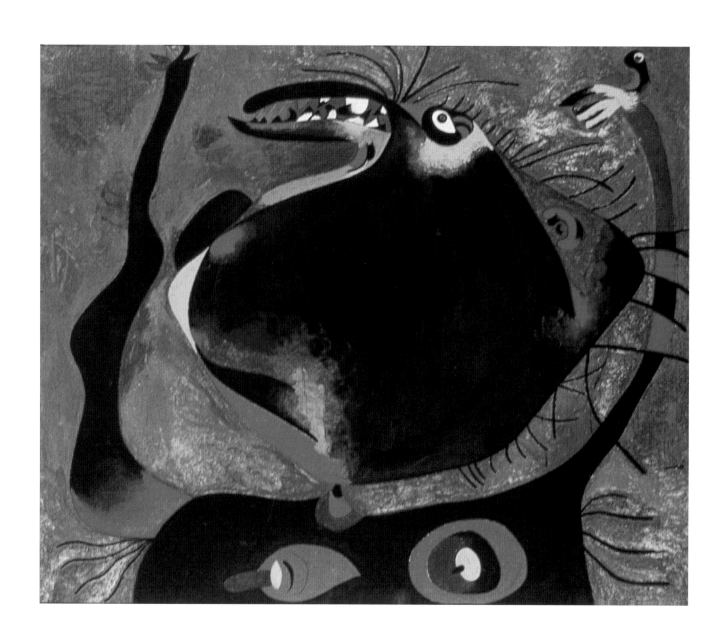

31. *Head of a Woman,*
1938. Oil on canvas,
45.72 x 54.93 cm.
Minneapolis Institute
of Arts, Minneapolis,
Minnesota.

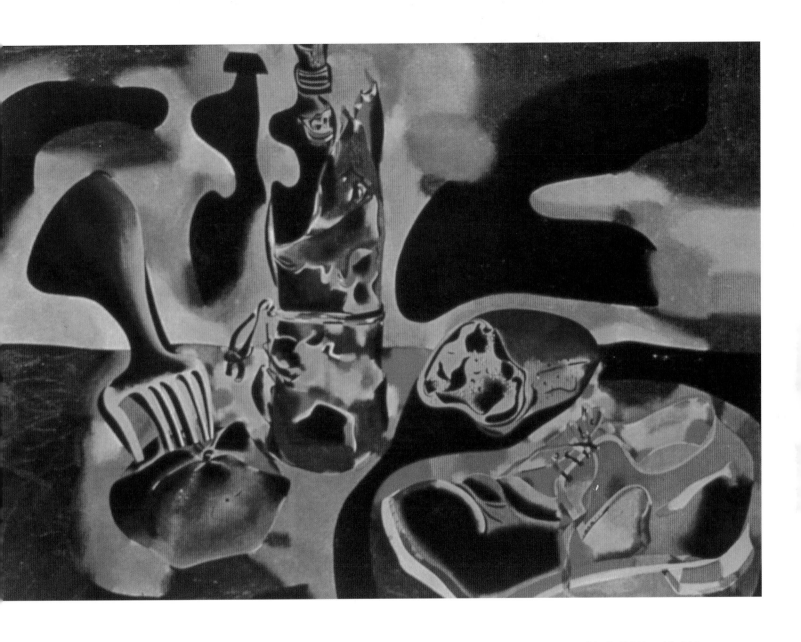

32. *Still Life with Old Shoe*, 1937.
Oil on canvas,
81.3 x 116.8 cm.
Museum of Modern Art, New York.

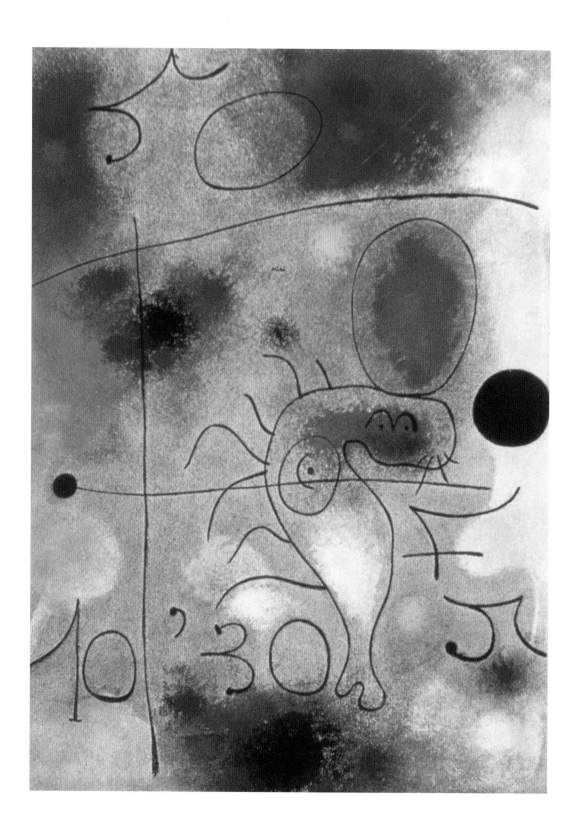

33. *The Circus,* 1937.
Oil and tempera
on celotex,
121.3 x 90.8 cm.
Meadows Museum,
Dallas, Texas.

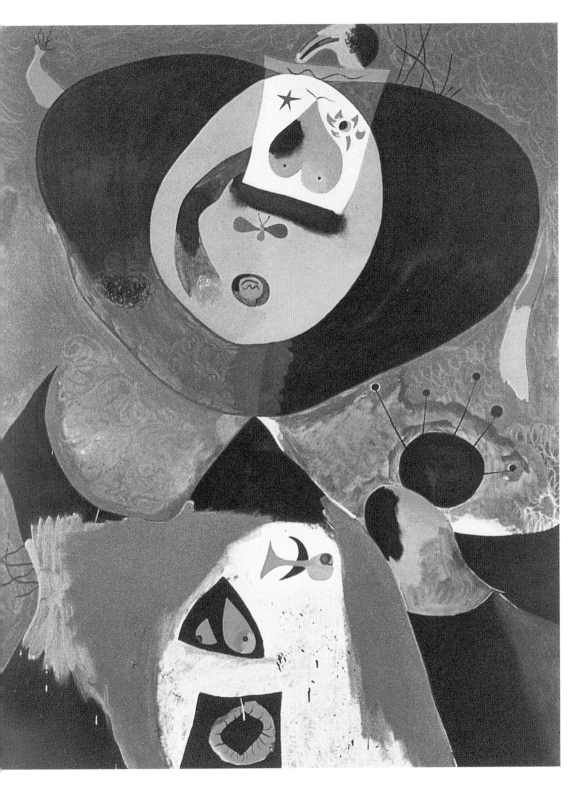

34. *Portrait I,* 1938.

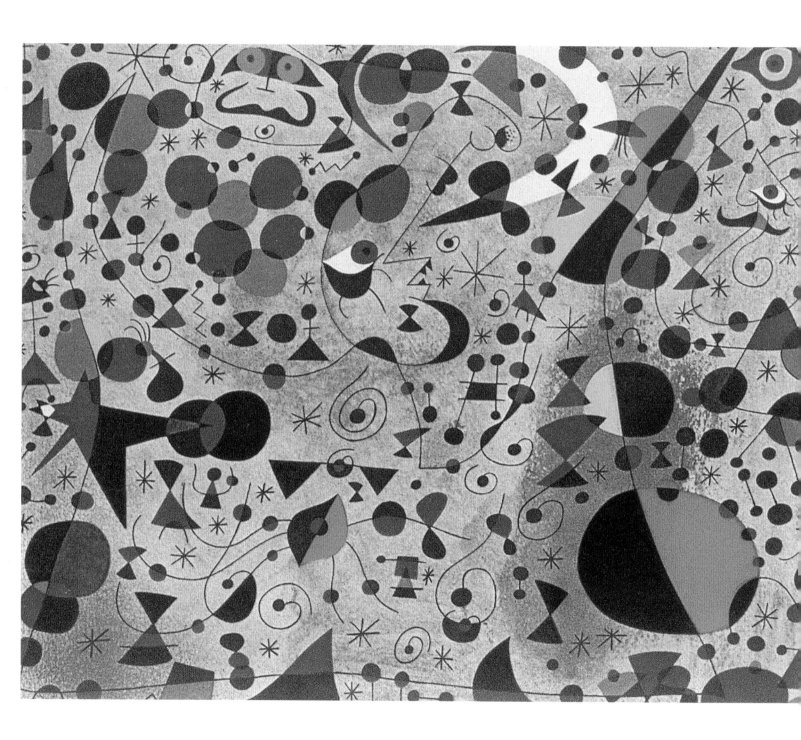

His work included a characteristic style of visual forms most often described as "biomorphic." Plants and animals received human-like characteristics, while humans were reduced to ciphered parts – an eye, a foot, a hand. Abstract shapes simply suggested living forms and thereby invited interpretation. In succeeding decades, the biomorphic representations of Miró were taken up and elaborated on by others like Picasso, Matisse, and Dali, becoming an "alternative to the prevailingly rectilinear structures of Cubism" and indeed the "dominant morphology of the post-Cubist years," according to William Rubin, curator of the 1973 retrospective of Joan Miró's art at New York's Museum of Modern Art.[22]

In the late 1920s and early 1930s, Miró tried to abandon painting. Attempting to delve into a more primeval creative state, he composed pieces out of found objects, some attached to a canvas as if a two-dimensional painting and some connected together sculpturally. *Spanish Dancer,* the first of this series, combines flat surfaces chosen for their texture – sandpaper, linoleum, crinkled paper – with other familiar objects – string and nails – into a composition oddly harmonious with the biomorphic shapes of color he had been applying to a canvas.

In company with his fellow Surrealists, Miró completed some three-dimensional constructions as well, often coming up with shocking combinations of materials – a vertebra and teeth glued to nails and blocks of wood – but his imagination seemed to steer him back to the flat form. A series of painting-collages done in 1933 gives a revealing glimpse into the way that Miró transformed visual realities into shapes and colors. In the collages, catalog engravings of tools and postcard illustrations of animals and human figures float on the page, barely interacting. In the paintings that follow, each flat-plane structure has evolved, the figures within it swelling into intersecting shapes. It is as if, to Miró, to paint a version of the collage is to bring it to life. In works like *Rope and People* (1935), he combined his fascination with objects and his sense of color, shape, and line.

In the public eye, Miró denounced painting. In 1931, a newspaper reporter from Madrid's *Ahora* interviewed Joan Miró for an article titled "Spanish Artists in Paris." In the interview, Miró determinedly refused to portray himself as a founder or even as a member of the Surrealist movement. "By the time I arrived at an understanding of Surrealism, the school was already established. I was swept along," he said. "I followed them, but not everywhere they went." He refused to allow himself to be labeled. "What I want to do above and beyond anything else is maintain my total absolute, rigorous independence."

The reporter played devil's advocate. "Nonetheless, you and your friends are the leaders of this movement," he insisted, asking where Surrealism was heading. "I personally don't know where we are heading," said Miró with defiance not only toward his interviewer but toward the movement of which he was seen as a leading member.

35. *The Poetess,* 1940.
Gouache and oil
wash on paper,
38.1 x 45.7 cm.
Private collection,
New York.

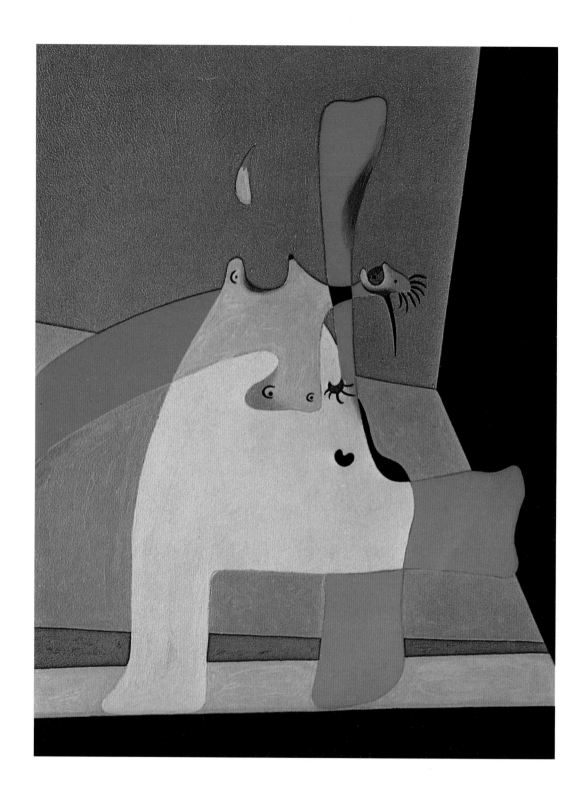

36. *Flame in Space and nude Woman*, 1932, Oil on carboard, 41 x 32 cm. Joan Miro Foundation, Barcelona.

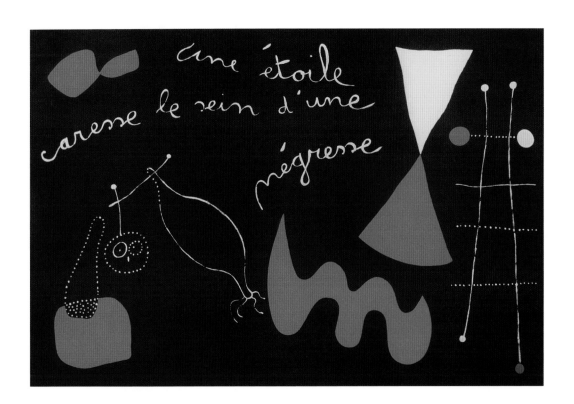

"The only thing that's clear to me is that I intend to destroy, destroy everything that exists in painting. I have an utter contempt for painting. The only thing that interests me is the spirit itself, and I only use the customary artist's tools – brushes, canvas, paints – in order to get the best effects…I'm not interested in any school or in any artist. Not one. I'm only interested in anonymous art, the kind that springs from the collective unconscious. I paint the way I walk along the street… When I stand in front of a canvas, I never know what I'm going to do – and nobody is more surprised than I at what comes out.[23]

As with the other Surrealists, Miró sought a state of creative productivity unfettered by conscious control. In this frame of mind, images of sexuality were just as likely – maybe more likely – to come forth as any other. Paintings of his from the early 1930s often blatantly resolve into shapes of the most suggestive body parts: mouths, tongue, teeth; feet and toes; penis, testicles, pubic hair; nipples, labia. Often these parts are attached to shapes not at all human, but their presence – and the irresistible implications they carry – turn the shape human after all, as seen in three different representations of *Woman* created in 1934.

37. *Une Etoile caresse le sein d'une négresse (Star caressing the breast of a negress),* Painting-poem, 1938. Oil on canvas, 130 x 196 cm. Tate Gallery, London

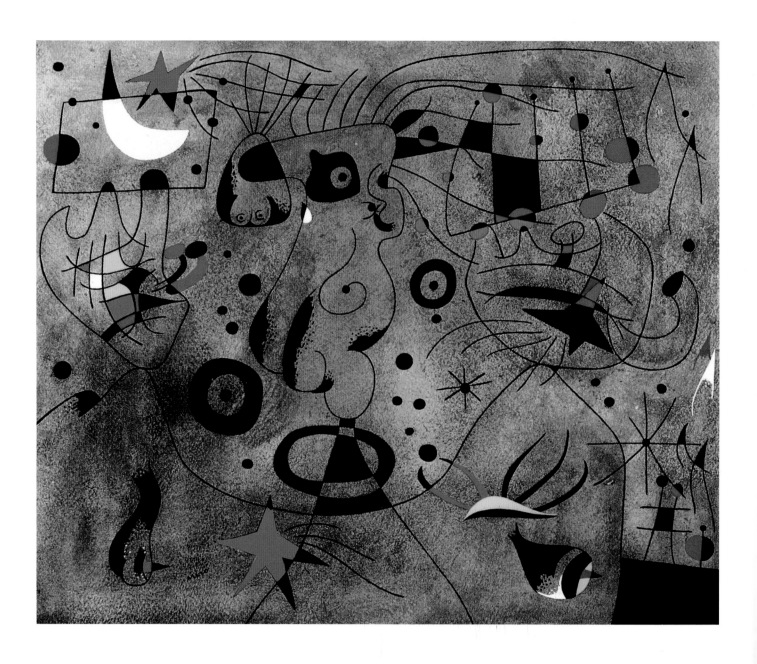

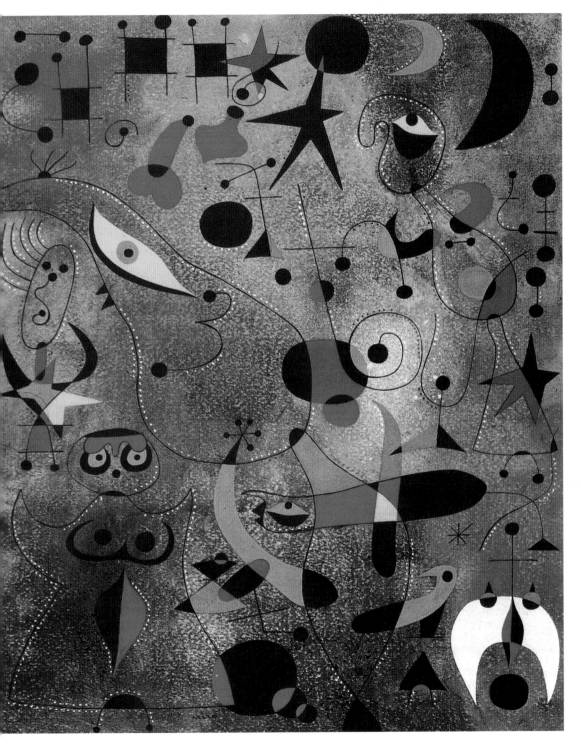

38. *Woman with Blond Armpit Combing Her Hair by the Light of the Stars* (of the *Constellation* series), 1940. Gouache and oil wash on paper, 38 x 46 cm. The Cleveland Museum of Art, Cleveland, Ohio.

39. *Awakening in the Early Morning* (of the *Constellation* series), 1941. Gouache and oil wash on paper, 46 x 38 cm. Kimbell Art Museum, Fort Worth, Texas.

40. *Ciphers and
Constellations in Love
with a Woman*, 1941.
Gouache and oil wash
on paper, 46 x 38 cm.
Art Institute of
Chicago.

41. *The song of the
nightingale at
midnight and the
morning rain*, 1940.
Gouache and oil wash
on paper, 38 x 46 cm.
Perls Galleries,
New York.

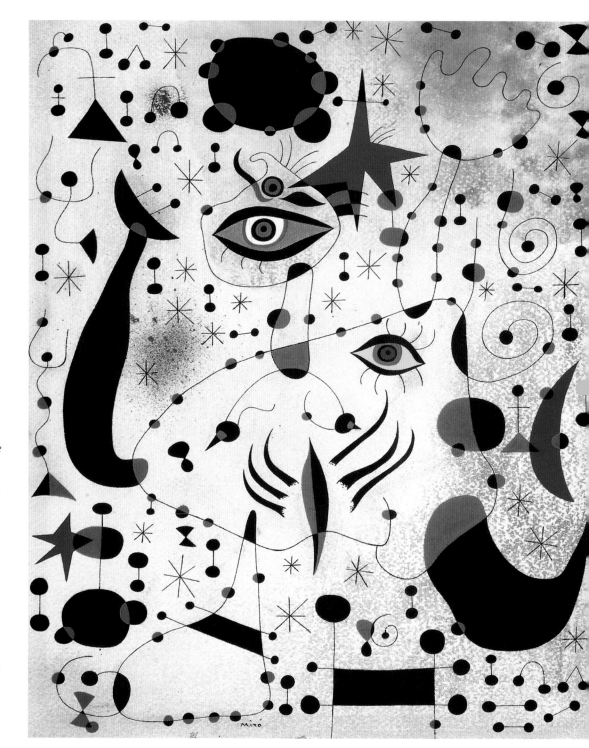

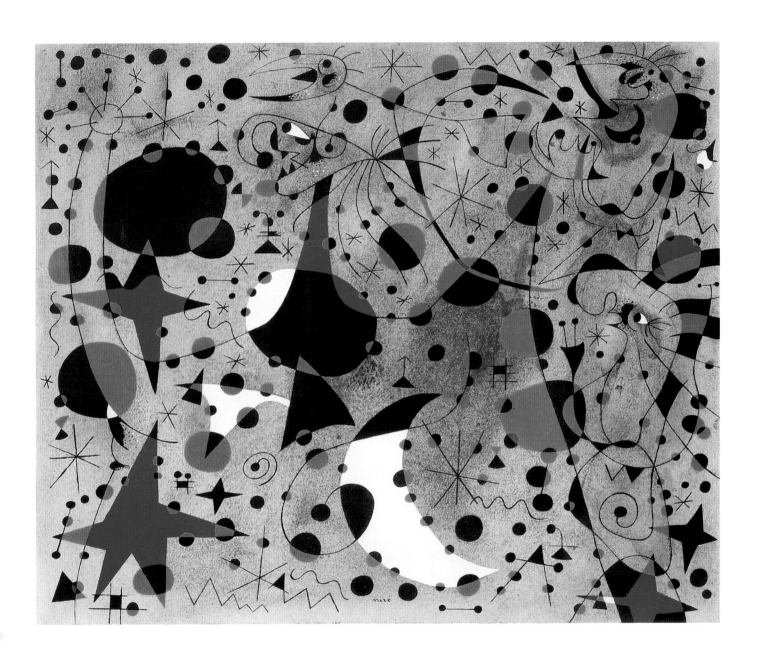

His paintings, wrote Miró in 1933, were born "in a state of hallucination, brought on by some jolt or other – whether objective or subjective – which I am not in the least responsible for." It was not a totally automatic process, however. "I struggle more and more to achieve a maximum clarity, force, and plastic aggressiveness – in other words, to provoke an immediate physical sensation that will then make its way to the soul."[24] By pursuing the discipline of finding shapes more primitive than representational reality, his art strived for a response more visceral than intellectual. Preparing for a 1935 gallery show in the United States organized by his new agent, Pierre Matisse, he promised pastels that were turning out to be "very painted."[25]

Through the 1930s, Miró's humanoid figures often metamorphosed into monsters, as if he was exploring the boundary line between fantasy and horror. *Personage* (1934) bares needle-sharp teeth. *Head of a Man* (1937) appears dented, its solitary eye hollow with fear. *Woman's Head* (1938) sets eyes going one way, nipples prominently pointing another. Miró's palette here combines primary colors with a large quantum of flat black. "Nothing in the painter's private life accounts for the upheaval," commented biographer Jacques Dupin on this period of Miró's work. "What seems to have changed was not so much Miró as the course of modern times around him…A form of barbarism, hitherto unknown in history, was now threatening European civilizations." The horrors of war and an impending holocaust entered the art of Joan Miró. Through the late 1930s, what had been "marvelous" now became "terror-stricken fantasy."[26]

The Spanish Civil War brought war and violence close to Joan Miró's heart. Military uprisings and the threat of further bloodshed throughout Spain forced his wife and child to move with him to Paris in 1936. Even though he was living apart from the violence, he could not help but visualize the way it was destroying his homeland. "Aidez L'Espagne," cried out the stencil poster he created on behalf of the Loyalist republican government under attack by right-wing revolutionaries. Miró handwrote a personal note on the poster, beneath the strong image of a man's face, crying out, his fist held high in defiance. "In the present struggle I see, on the Fascist side, spent forces; on the opposite side, the people, whose boundless creative will gives Spain an impetus which will astonish the world."[27] For the Spanish pavilion at the Paris World's Fair of 1937, Miró created a large mural, 18 by 12 feet in size, titled *The Reaper,* or *Catalan Peasant in Revolt.*

Images of the mural still exist, but the original six-panel creation was lost when the pavilion was dismantled. The painting presented a distinct contrast to Pablo Picasso's parallel commentary on the war, *Guernica*, also created for the 1937 Paris exposition. In Miró's, a fantastical head wearing the red cap of a Catalan peasant looks with a mixture of anger, horror, and wonder up into a starry sky. *The Reaper* combined many of the symbols of his homeland that meant the most to Miró: the peasant, individuality and rebelliousness, the stars in the sky.

42. *The Escape Ladder,* 1940. Gouache and oil on paper, 73 x 54 cm. Private collection.

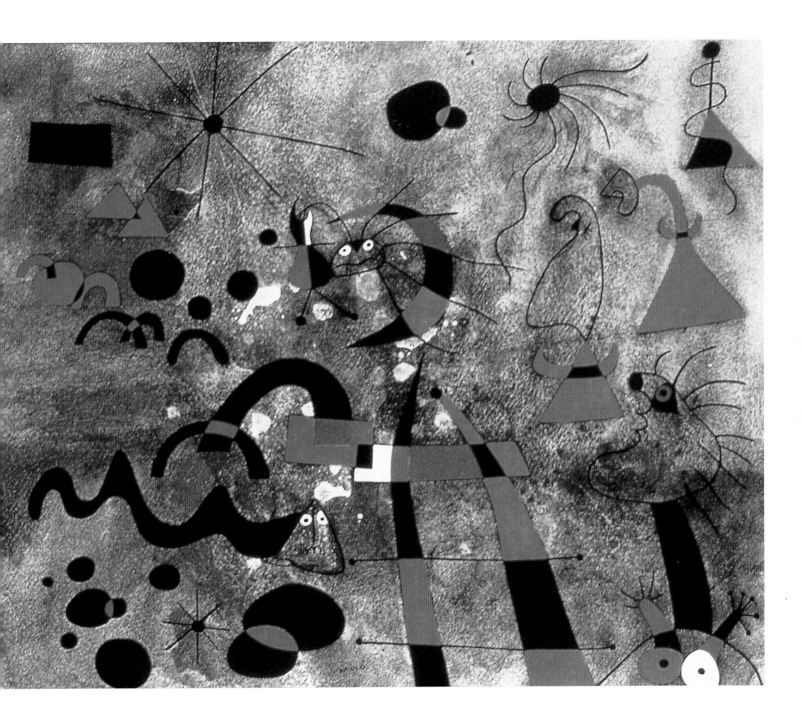

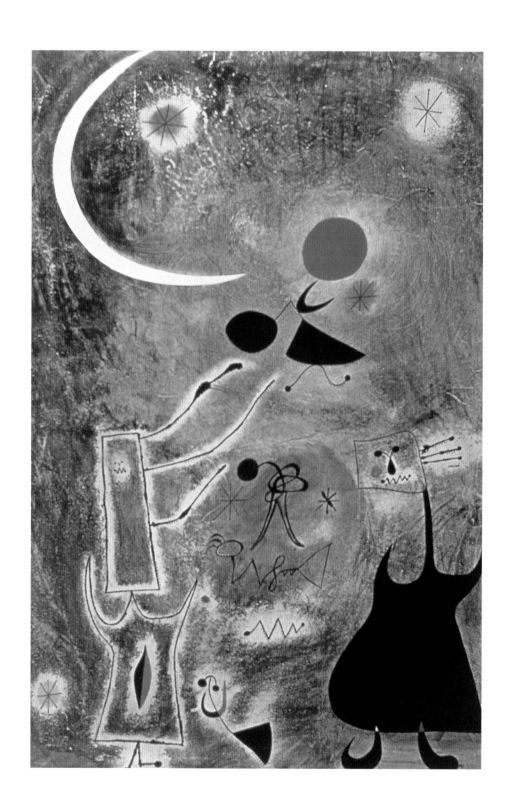

43. *Woman and Bird in front of the Sun,* 1942.

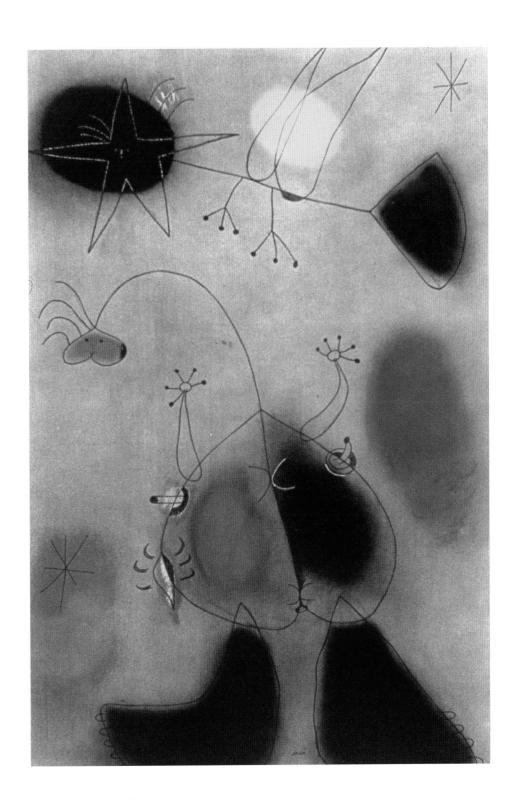

44. *Woman, Bird and Stars,* 1942. Pastel and pencil on paper, 106.6 x 71.1 cm. Miró Foundation, Barcelona.

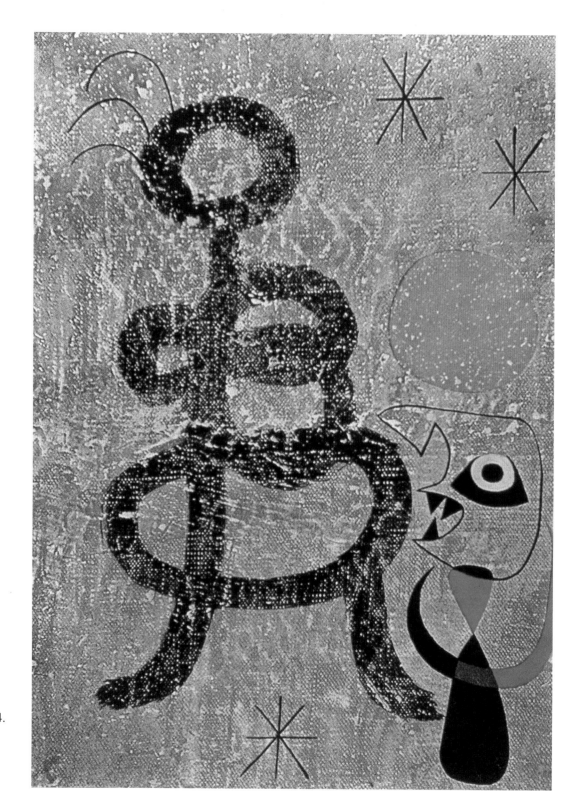

45. *Woman and Bird in
 front of the Sun,* 1944.

46. *Red Sun gnaws the
 Spider,* 1948.

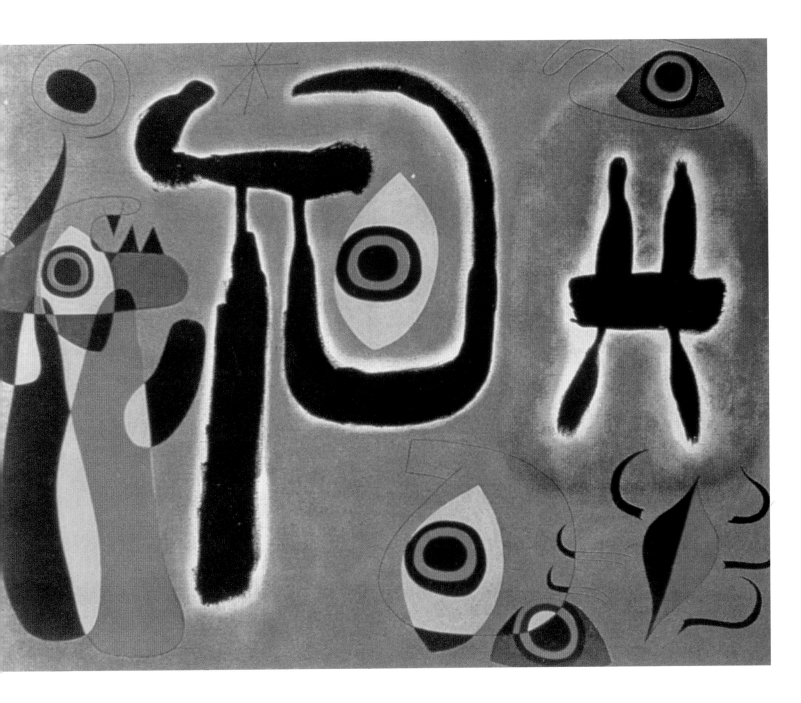

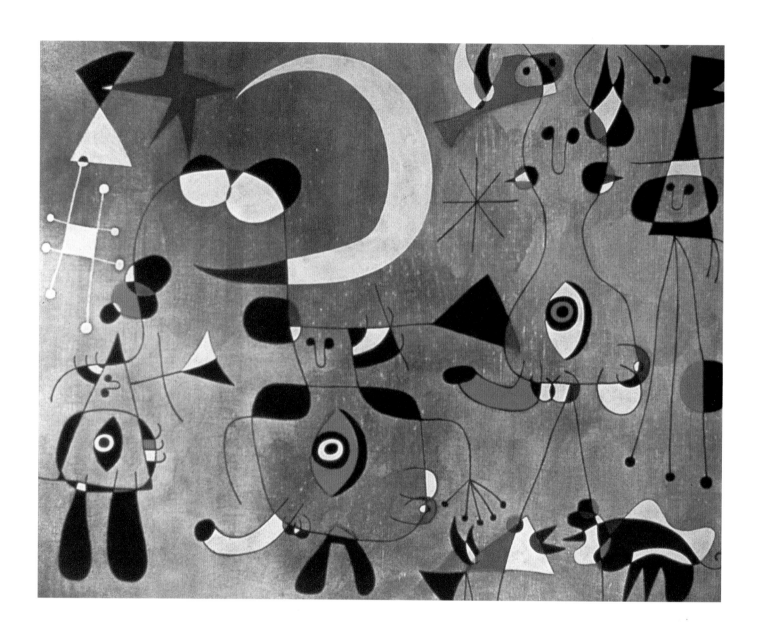

While this painting portrayed some modicum of hope, another painted at the same time betrayed a sense of hopelessness in its eerie, unnatural representation of the everyday world: *Still Life with an Old Shoe* (1937). Called by his biographer Jacques Dupin "one of the strangest and most important of his paintings," this painting takes a mundane set of objects – a forked potato, a wine bottle, a chunk of bread, and a shoe – and turns them disturbingly fluid, fractured, and unreal. "Taking these objects in all their humble simplicity, the artist proceeded to put them through an alchemical process at the end of which we are presented with an apocalyptic vision, a landscape in searing confusion, going up in flames, the portrait of a world gone mad, a portrait of martyrized Spain." It is this painting, says Dupin, and not *The Reaper,* which one should compare with Picasso's *Guernica.*[28]

Miró escaped the Spanish Civil War by moving to Paris. Now the approach of World War II sent him back to Spain. He had been away from his homeland for five years when he returned to Palma de Mallorca. Something about the landscape, the escape, and the childhood memories that these experiences brought back to him allowed Joan Miró to complete the transcendental series of paintings for which he would be remembered ever after: the paintings collectively called *Constellations.*

He had begun these paintings while in the Normandy countryside, in Varengeville-sur-Mer, a tiny village near Dieppe where he lived from August 1939 to May 1940. He was so caught up with his work that he did not understand how that location put him into the path of the escalating war. He was busy creating the techniques and sensibility that would carry through a tight series of 23 paintings.

He began by moistening his paper, scratching its surface and stirring up texture as background to the firmament he was creating. Familiar imagery floated onto the page – eyes, stars, birds, faces, ribs – but also simple geometric shapes – triangles, circles, crescents, swashes. Some shapes are flat black, others primary colors, but all interconnect within the frame, so that the totality is as much the interest of the painting as its component parts.

Miró's friend André Breton, the premier Surrealist, wrote text to accompany the New York gallery presentation of these paintings. He described the careful work of the artist, since to gaze at these paintings is to participate in their creation: "The hand engages in patient operations of rubbing, abrading, impregnating, massaging into life variously pigmented, variously somber or transparent gleams over the entire surface, realizing imperceptible transitions from one color to another or blending them in a single misty cloud."[29] He also described the series itself: "They participate in and yet differ from each other in the manner of bodies in the aromatic and cyclic series in chemistry," wrote Breton. "Considered simultaneously, both in succession and as a whole, each of them takes on the necessity and value of a member in a mathematical series."[30]

47. *Personages in the Night,* 1949.

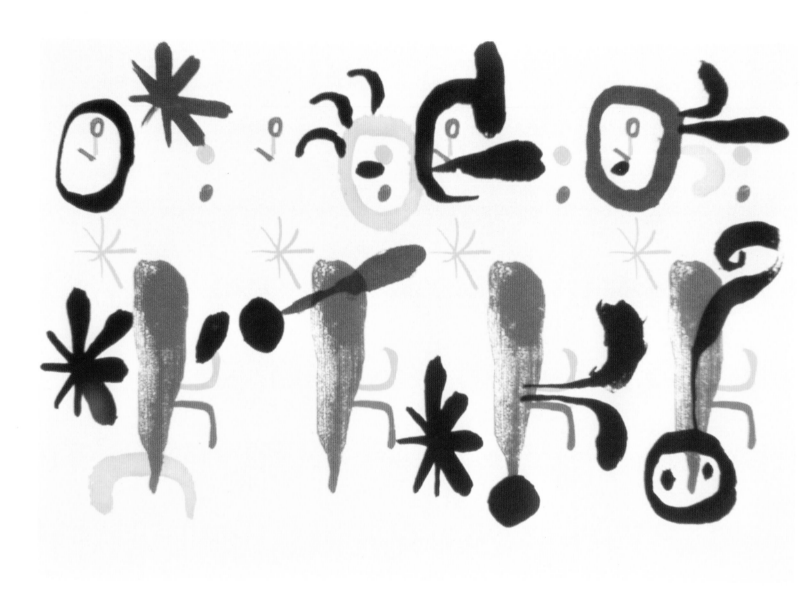

48. *The Bird Catchers,*
1950.
55.5 x 38.1 cm.

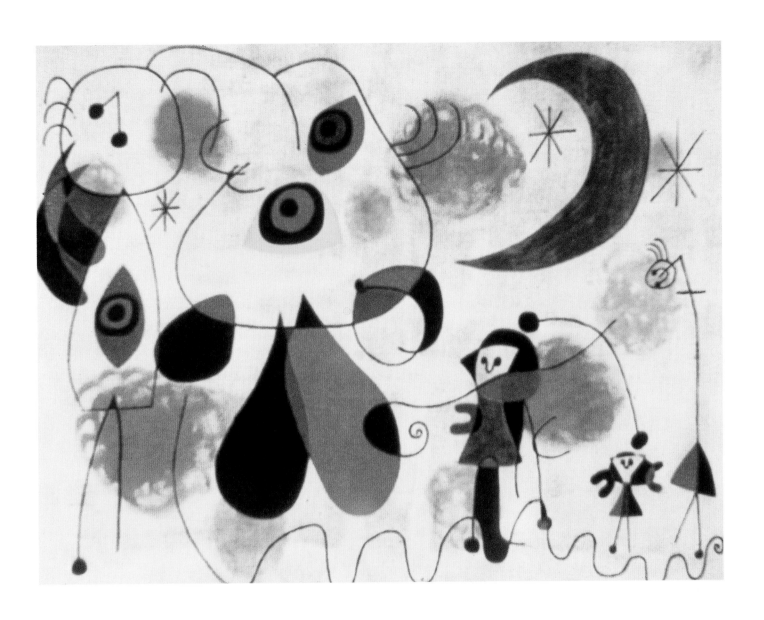

49. *Woman, Moon and Birds,* 1950.

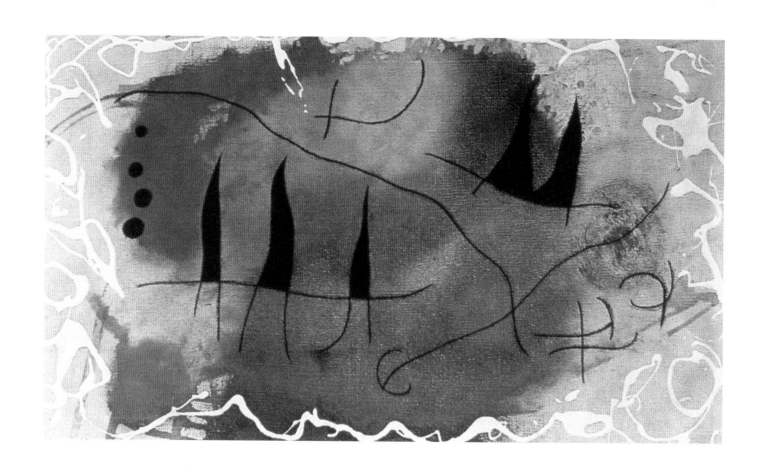

50. *Dawn II/II*, 1959.

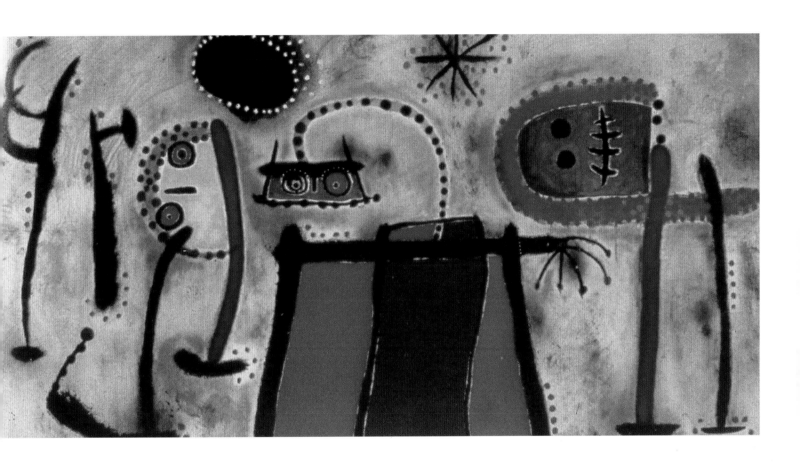

51. *Painting,* 1953.
Oil on canvas,
195 x 378 cm.
Guggenheim Museum,
New York.

Miró's *Constellations* were like the elegant results of a game of chance, believed Breton – which is close to the way the artist himself described their creation. "I would set out with no preconceived idea," he said. "A few forms suggested here would call for other forms elsewhere to balance them. These in turn demanded others. It seemed interminable... I would take [a gouache] up day after day to paint in other tiny spots, stars, washes, infinitesimal dots of color in order finally to achieve a full and complex equilibrium."[31]

Joan Miró's *Constellations* were shown in New York at the Pierre Matisse Gallery in 1945, making them the first European works brought to the United States after the end of the Second World War. It was not just the timing but also their spirit that made it seem to all that these paintings contained a message both apocalyptic and consoling. "At a time of extreme perturbation," wrote André Breton, "it seems that by a reflex striving for the purest, the least changeable, Miró let go with the full range of his powers, showing us what he could really do all the time."[32]

By 1956, as the artist turned 63, Joan Miró's wife insisted that he hire the services of Joseph Lluis Sert, a dear friend and architect, to design the studio he had always wanted. Many years before, in 1938, Miró had written an article titled "Je rêve d'un grand atelier" – "I dream of a big studio." In it, he admitted that in all the years and summers he had painted in Spain, he had never had a real studio.

"In the early days I worked in tiny cubicles where there was hardly enough space for me to get in. When I wasn't happy with my work I banged my head against the walls. My dream, when I am in a position to settle down somewhere, is to have a very large studio, not for reasons of brightness, northern light, etc...which I don't care about, but so that I can have space, lots of canvases, because the more I work the more I want to work."[33]

Now it was time to build one. Sert designed a remarkable space, with brilliant white walls and long roofs shaped like bird wings. Miró kept it, as he always had kept his working spaces, impeccably neat and clean. It allowed him to begin working in larger forms – tapestries and murals, monumental sculptures, paintings bigger than he had ever painted before.

It is ironic that a man once quoted as wishing to see "the murder of painting" would gain international renown primarily in that medium. As soon as success gave him the freedom to do so, Joan Miró gleefully moved into other media, exploring them with the same intrepid originality and exceeding expectations by transcending tradition, just as he had done with his painting.

In 1944 he reconnected with his old friend, Papitu Llorens Artigas, a fellow student of Gali's who had become a master ceramicist in Barcelona. The two began a collaboration that would continue for years, resulting in plates, vases, and tiles that took ceramics to a new level of expression and art.

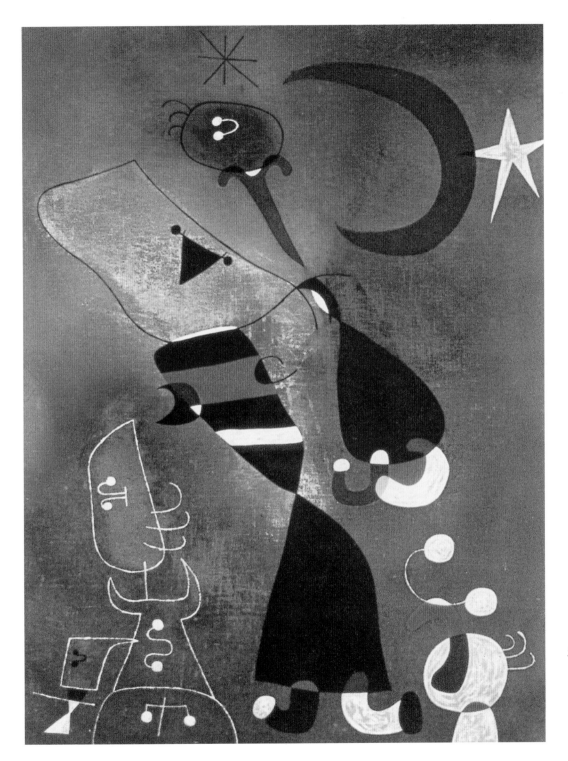

52. *Woman and Bird by Moonlight*, 1949.
Oil on canvas,
81.5 x 66 cm.
Tate Gallery, London.

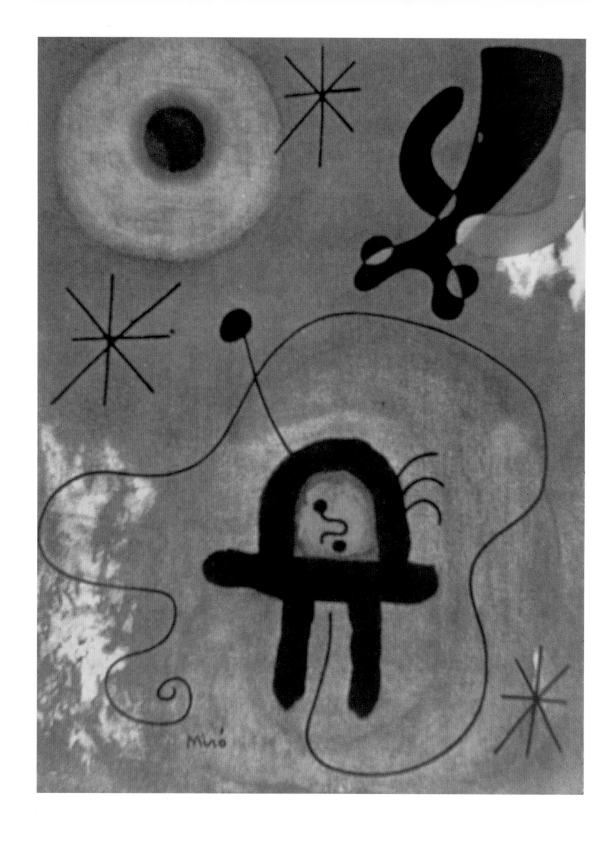

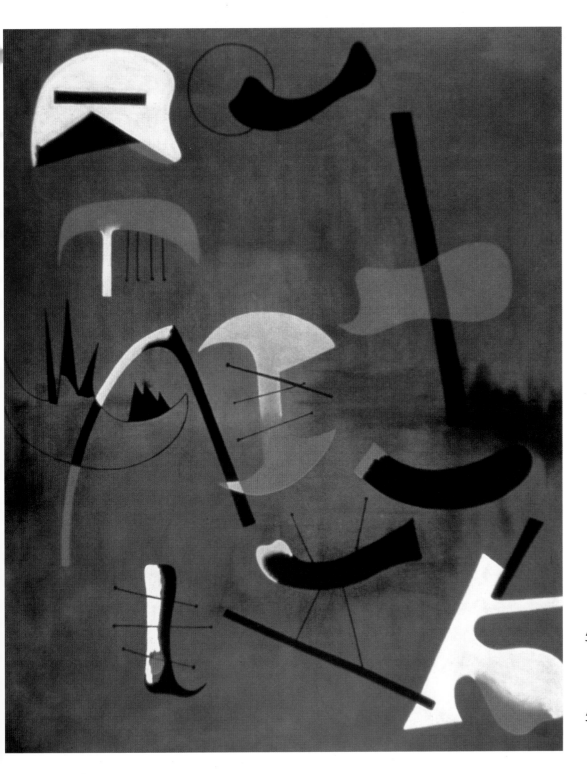

53. *The Mauve of the Moon*, 1952. Lithography.

54. *Composition*, 1963. Narodni Gallery, Prague.

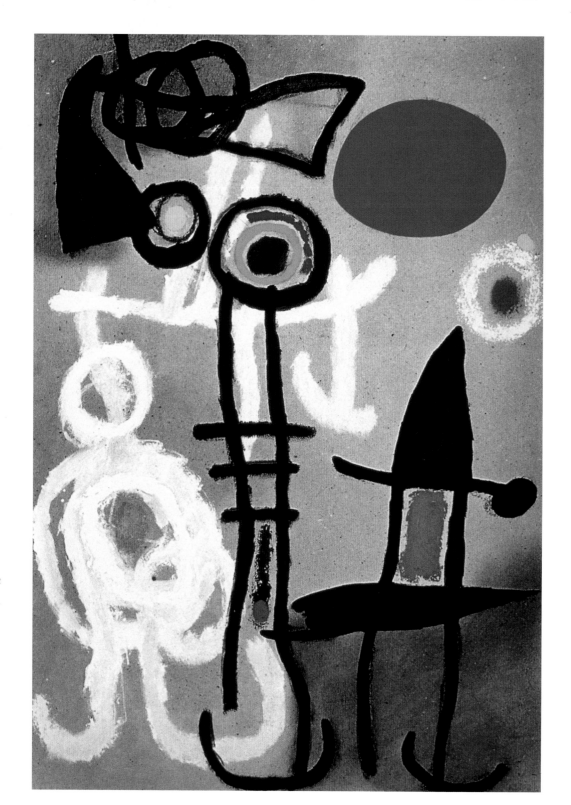

55. *Personage and Bird in
front of the Sun,* 1963.
Oil on cardboard,
106.6 x 73.6 cm.
Private collection.

56. *Personage and Bird,*
1963.
Oil on cardboard,
75 x 105 cm.
Private collection.

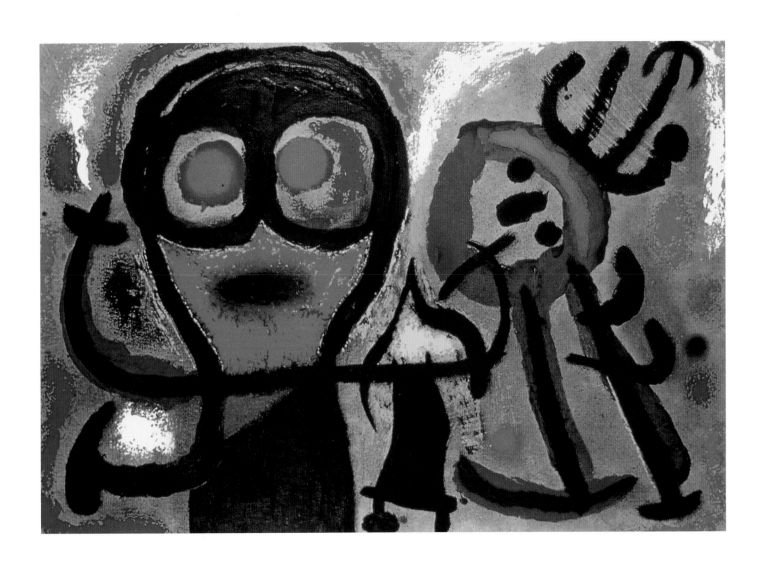

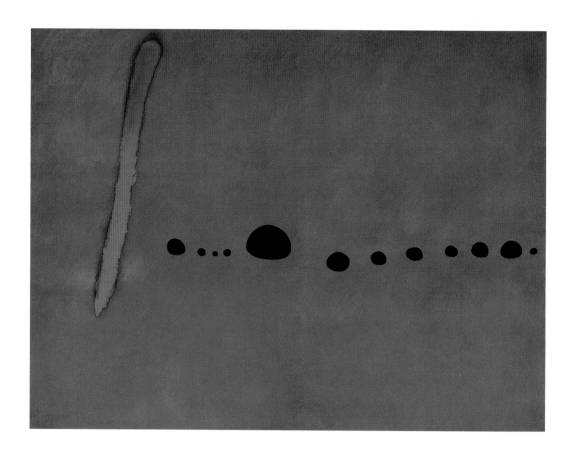

Glaze could be paint for outlining and molding three-dimensional blobs, their sheen contrasting with the rough clay texture. Miró's work in ceramics led to his being invited by UNESCO to create two tile walls, *The Wall of the Moon* and *The Wall of the Sun*, for the organization's Paris headquarters, completed in 1958. He and Artigas continued to work together on monumental walls. Tile murals by Miró and Artigas now engage the regard of passersby in Spain, Japan, and the United States.

Working in a variety of sculptural media, Joan Miró made a happy transition into the realm of sculpture as well. Beginning with small bronzes, seemingly embodiments of the fantasy figures whom he had sent dancing on paper, Miró moved onto bigger forms and, finally, an entire labyrinth of statuary which today animates the grounds of the Maeght Foundation in Saint-Paul-de-Vence on the Cote d'Azur in France.

Early in his career, Joan Miró had ventured outside the Surrealist fold and painted a backdrop curtain for the Ballets Russes' 1926 production of *Romeo and Juliet*. His fellow Surrealists balked, considering classical ballet an art of the aristocracy, but Miró paid

57. *Blue II*, 1963.
Oil on canvas,
270 x 355 cm.
Musée National d'Art
Moderne, Centre
Georges Pompidou,
Paris.

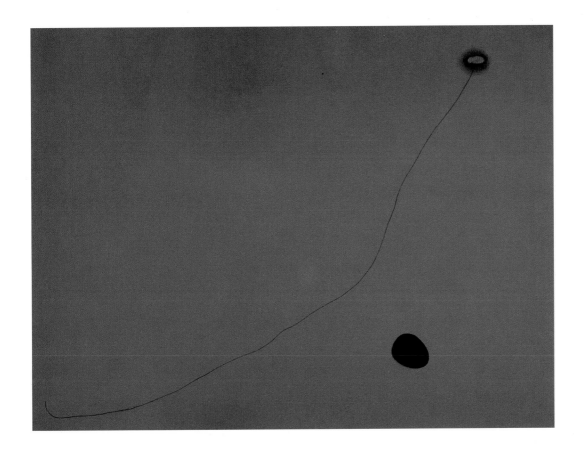

such doctrinaire matters no thought. He designed not only curtains but also costumes, sets, and props for the Ballets de Monte Carlo's *Jeux d'enfants* in 1932. Theatrical projects did not come his way again until 1978 when, at the age of 85, Miró created costumes and curtains for *Mori el Merma*, a political satire. Overstuffed headdresses and gourd-shaped costumes turned human bodies into the biomorphic shapes so characteristic of Miró. "Only a very old painter could maintain such an infantile hand with such grace," wrote one critic in describing the play's costumes – more like masks and puppets – designed by Miró.[34]

As Joan Miró turned 80, in 1973, he was recognized the world around, not only as a painter whose work played an important part during the formative years of the 20th century, but also as an artist of the world whose vision and industry touched the daily lives of millions. Fame infuriated him. "I'd like to go out saying to hell with everything," he said in 1969.[35] To wealth he responded with even more outrage and contempt. "A while ago I burnt some canvases," he told his grandson a few years later.

58. *Blue III*, 1963.
Oil on canvas,
270 x 355 cm.
Musée National d'Art
Moderne, Centre
Georges Pompidou,
Paris.

"I burnt them for artistic and professional reasons and the results were very beautiful; I also burnt them in order to cock a snook at people who say that these canvases are worth a fortune... I'm sorry to say that people do not see canvases, they only see dollars."[36]

Joan Miró spent the last decades of his life, aside from travel, in his homeland of Catalonia. His grandson, Joan Punyet Miró, remembers that he acquired a new habit in his later years. Just as he had for years filled his canvases with constellations of interesting shapes and colors, so now he collected objects from the Catalan countryside. "He would make a collection of unusual items," wrote the younger Miró, "strange and unexpected objects that, when removed from their normal context and gathered into a homogeneous group, would open a rich and fertile seam of possibilities, propitious to impulsive digressions."

In 1978, his grandfather told him that this "present absorption in all these bits and pieces" was a new phenomenon. "I've been hypnotized," he said. "When I go for a walk I don't hunt for objects as if I were looking for mushrooms. There's a sudden force, bang! like a magnetic force that makes me look down at a certain moment." From those moments, he would bring home shells, roots, bones, snail shells, bat skeletons, recalled his grandson: new constellations, chance combinations of shape and color that amount to beauty, such as Joan Miró himself had created for all time.

Joan Miró died on Christmas Day, December 25, 1983, at the age of 90. During the previous year his life career had been celebrated by retrospective exhibitions in both New York and Barcelona. In recent years he had received honorary doctorate degrees from Harvard and Barcelona Universities and had been granted Spain's Gold Medal for Fine Arts.

He had overseen the establishment of the Fundació Miró in Barcelona, with headquarters designed by Josep Lluis Sert, an exhibition hall and center for the study of contemporary art in Barcelona. His paintings and three-dimensional works formed part of the permanent collections of art museums around the world. A number of those paintings had become so much a part of the cultural vocabulary, they would be recognized – and enjoyed – by educated people, young and old, around the world.

In his last years, Joan Miró spoke to his grandson of his lifelong love of Catalonian folk art – the natural forms, the independent spirit, the naiveté that is both beautiful and surprising. "Folk art never fails to move me," he said. "It is free of deception and artifice. It goes straight to the heart of things." In speaking of the art that came from the country that had nourished him, Joan Miró found the best words to describe himself. With his honesty, spontaneity, and childlike enthusiasm for shape, texture, and color, he created a universe of artworks sure to delight, puzzle, and reward.

59. In collaboration with Joan Gardy-Artigas, *Woman and Bird*, 1981-1982. Concrete, partially covered by ceramic pieces, H : 2200 cm. Parc Joan Miró, Barcelona.

60. *Jeune Fille s'évadant (Girl Escaping)*, 1968. Painted bronze, 135 x 50 x 35 cm. Private collection.

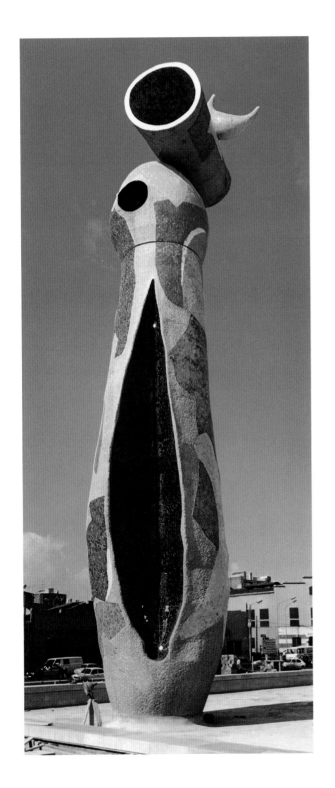

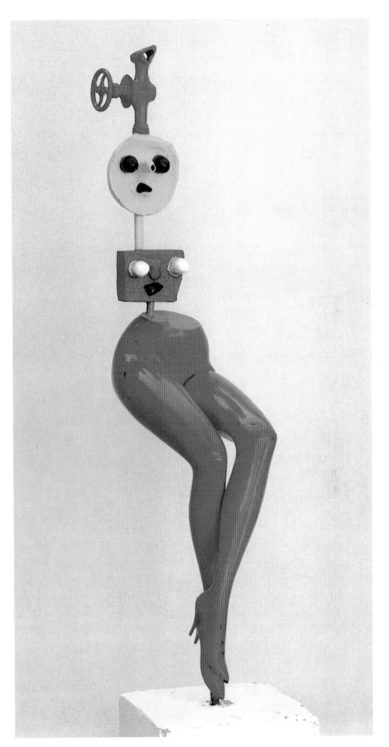

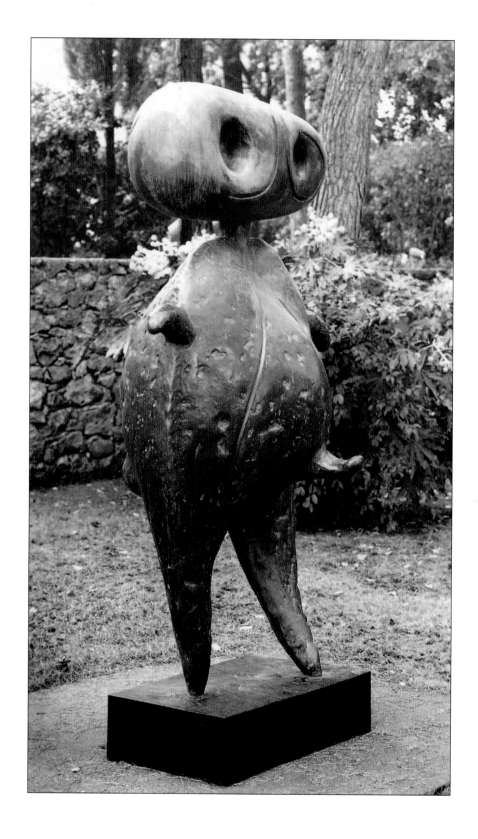

61. *Personage,* 1970.
Bronze,
200 x 200 x 100 cm.
Private collection.

BIOGRAPHY

1893: April 20. Birth of Joan Miró in Barcelona. Parents: Miguel Miró Adzerias, silversmith and watchmaker, Dolores Ferra, daughter of a cabinetmaker.

1897: May 2. Birth of Joan Miró's only sister, Dolores.

1900: Miró enters primary school in Barcelona and attends optional drawing classes after school.

1901: The earliest preserved drawings by Miró date from this year.

1907: Enrolls in School of Commerce in Barcelona. Also attends art classes at the Lonja School of Industrial and Fine Arts.

1911: Ill health forces him to leave his job. He convalesces at his parents' new farm in Montroig.

1912-15: Enrolls in Francisco Gali's art academy in Barcelona.

1913: Joins friends in forming the Sant Lluch circle of artists in Barcelona.

1915: Begins a three-year, three-month per year obligation to the military, serving October, November, and December of 1915, 1916, and 1917.

1916: Art dealer Josep Dalmau admires several of Miró's works, especially his landscapes.

1917: An exhibition of French art in Barcelona makes a strong impression on Miró. He meets Francis Picabia, editor of the Dadaist magazine, *391*.

1918: First one-man show at the Dalmau Gallery in Barcelona.

1920: First trip to Paris. Meets his countryman Pablo Picasso, who acquires Miró's *Self-Portrait*. Takes part in the Dada Festival at Salle Gaveau.

1921: Returning to Paris, he shares a studio at 45 rue Blomet, next door to André Masson. Masson introduces him to Paul Klee and others. Through Picasso, Miró meets art dealers Paul Rosenberg and Daniel-Henry Kahnweiler.

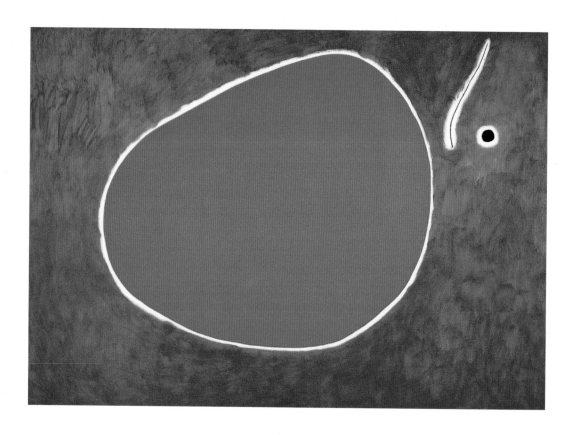

1920-21: Works on *The Farm*, the last of his stage of poetic realism.

1921: His first solo show in Paris, at Galérie La Licorne, is commercially unsuccessful.

1923-24: Paints *The Tilled Field* during summer in Montroig. Socializes with artists and poets in Paris including Antonin Artaud, Jean Dubuffet, Paul Eluard, Raymond Queneau, Ernest Hemingway, and Ezra Pound.

62. *The Dragonfly's Flight to the Sun*, 1968. Oil on canvas, 174 x 224 cm. Private collection, Paris.

1925: Solo exhibition of Miró's work at the Galérie Pierre, a success. All the members of the Surrealist group sign the invitation for the exhibit.

1926: Miró and Max Ernst work on the ballet sets for *Romeo and Juliet* for Diaghilev's *Ballets Russes*. Miró's father dies in Montroig.

1927: Relocates to Montmartre.

1928: Produces first object-collages. Visits Holland, providing inspiration for series of "Dutch Interiors." Major exhibition of 41 works at Galérie Bernheim. All 41 pieces in the exhibit sell.

1929: October 12. Miró marries Pilar Juncosia in Palma de Mallorca. They move to Paris. Paints a series of "Imaginary Portraits."

1930: July 17. The Mirós' daughter, Maria Dolorés, born in Barcelona. A solo exhibit of Miró's work opens at the Valentine Gallery in New York, first one-man show in the United States.

1932: Designs curtain, sets, costumes, and props for ballet, *Jeux d'enfants,* of Ballets Russes de Monte-Carlo. Exhibits at the Galérie Pierre in Paris and first one-man show at the Pierre Matisse Gallery in New York.

1933: Works on series of 18 collages and does paintings from them.

1936: Miró, wife, and daughter leave Spain for Paris, fleeing the Spanish Civil War. Museum of Modern Art in New York includes Miró in its major exhibition, *Fantastic Art, Dada, Surrealism.*

1937: Designs political poster, "Aidez l'Espagne." Commissioned to create large mural painting for the Paris World Fair.

1940: Miró begins the series of gouaches known as the "Constellations" at Varengeville and completes it the following year in Spain. After Germans bomb Normandy, Miró takes family to Palma de Mallorca.

1941: The Museum of Modern Art in New York holds a major retrospective of his work. J. J. Sweeney publishes first monograph on Miró and his art.

1942: Develops "Woman, Bird, and Stars" theme in a variety of materials, particularly watercolor, gouache, and ink.

1944: With Artigas, Miró begins to produce ceramics. His mother dies on May 27.

1946: Produces first bronze sculptures.

1947: First trip to United States. Produces mural for Cincinnati's Terrace Plaza Hotel.

1948: Returns to Paris. Miró has his first solo exhibition at the Galérie Maeght.

1950: Walter Gropius commissions a mural painting for the dining room, Harkness Graduate Center, Harvard University.

1955: Paintings on cardboard.

1958: Inauguration of UNESCO murals, which win Guggenheim International Award.

1960: With Artigas, creates ceramic mural for Harkness Commons, Harvard University, to replace mural painting.

1962: Retrospective at Musée National d'Art Moderne in Paris.

1964: Opening of the Fondation Maeght in Saint-Paul-de-Vence, including Miró's Labyrinth of sculptures.

1966: First monumental bronze sculptures. Retrospective at the National Museum of Art in Tokyo.

1967: Installation of ceramic mural by Miró and Artigas at the Solomon R. Guggenheim Museum in New York. Receives the Carnegie International Grand Prize for Painting.

1968: Exhibitions held in honor of Miró's 75th birthday. Receives honorary doctorate from Harvard.

1972: Fundació Joan Miró, Centre d'Estudis d'Art Contemporani founded in Barcelona. Sert commissioned to design the building.

1974: 80th birthday celebration, "Miró 80 Vuitanta," held in Palma de Mallorca at the College of Architects.

1976: Installation of ceramic paving in the Pla de l'Os, Barcelona.

1978: Monumental sculpture in *La Defénse*, Paris. Performances of *Mori el Merma*, with sets and costumes by Miró. Retrospective in Madrid.

1979: Unveiling of stained glass windows made with Marcq at Fondation Maeght.

1980: Receives Gold Medal for Fine Arts from Spain's King Juan Carlos.

1983: Events and exhibits commemorate Miró's 90th birthday. Monumental sculptures are unveiled in Chicago, Illinois; Houston, Texas; Barcelona, and Palma.

1983: December 25. Joan Miró dies at Palma de Mallorca. On December 29, he is buried in the family vault at the Montjuïc Cemetery in Barcelona.

63. *Sobreteixim XVII*,
 1973.
 Burlap, paint collage,
 240 x 142.2 cm.
 Miró Foundation,
 Barcelona.

LIST OF ILLUSTRATIONS

NOTES

1 Letter to Jacques Dupin, 1957, in *Joan Miró: Selected Writings and Interviews*, ed. Margit Rowell, New York: Da Capo Press, 1992, p. 44.

2 Jacques Dupin, *Joan Miró: Life and Work*, New York: Harry N. Abrams, p. 47.

3 Ibid., p. 49.

4 Joan Punyet Miró, *Miró in His Studio*, London: Thames and Hudson, 1996, p. 9.

5 Dupin, p. 54.

6 "Dadaism," website on "Electro-acoustic music," URL: < http://www-camil.music.uiuc.edu/Projects/EAM/Dadaism.html > accessed 2/24/04.

7 Rowell, p. 57.

8 Ibid., p. 63.

9 Ibid., 72.

10 Dupin, p. 92.

11 Dupin, p. 99.

12 Francesc Català-Roca, *Miró: Ninety Years*, text by Lluis Permanyer, Seacaucus, NJ: The Wellfleet Press, 1989, part III.

13 Dupin, p. 100.

14 Català-Roca, part II.

15 Dupin, p. 139.

16 J. P. Miró, p. 5.

17 Ibid., p. 6.

18 Rowell, p. 11.

19 Dupin, p. 154.

20 William Rubin, *Miró in the Collection of the Museum of Modern Art*, New York: MOMA, 1973, p. 32.

21 Rowell, pp. 1-3.

22 Rubin, p. 37.

23 Rowell, pp. 116-117.

24 Ibid., p. 122.

25 Ibid., p. 124.

26 Dupin, pp. 262, 265.

27 Rubin, p. 72.

28 Dupin, pp. 293-294.

29 Rubin, p. 81.

30 Dupin, p. 356.

31 Rubin, p. 81.

32 Dupin, p. 360.

33 J. P. Miró, p. 6.

34 Jean-Pierre Leonardini, at URL < http://www.festival-automne.com/public/ressourc/publicat/1982ouvr/mile137.htm > , accessed 2/22/04.

35 J. P. Miró, p. 15.

36 Ibid., p. 11.